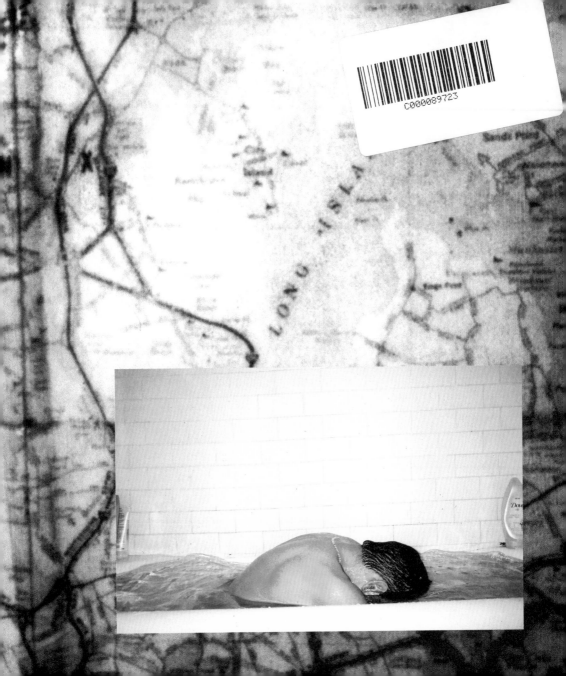

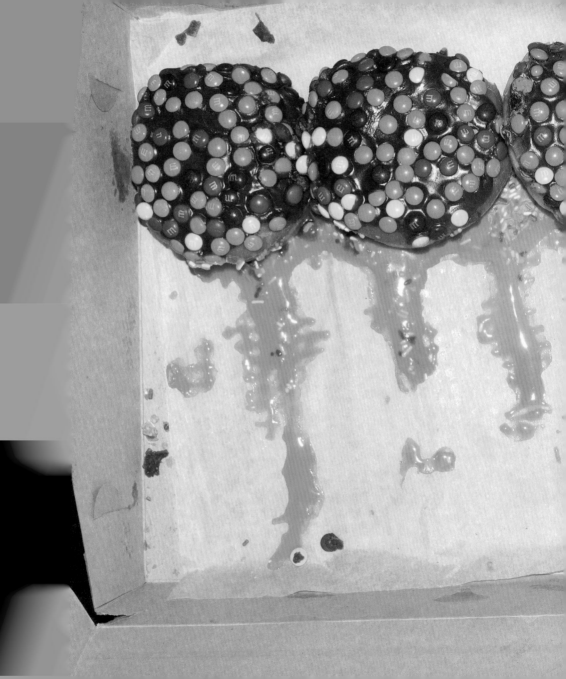

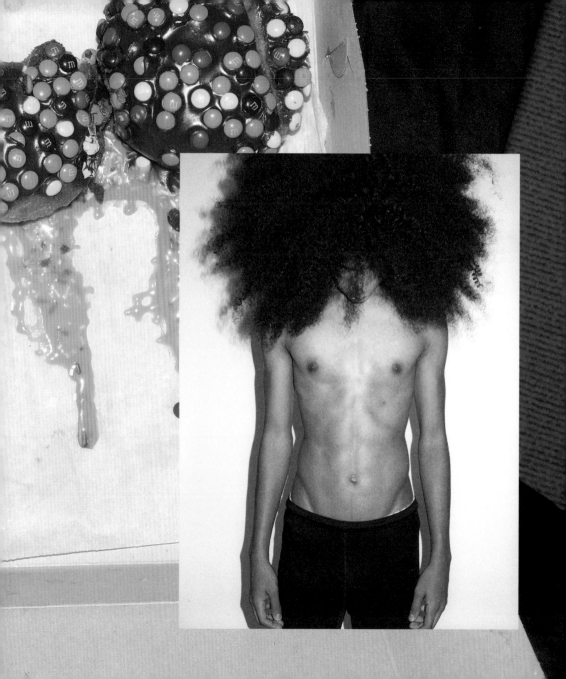

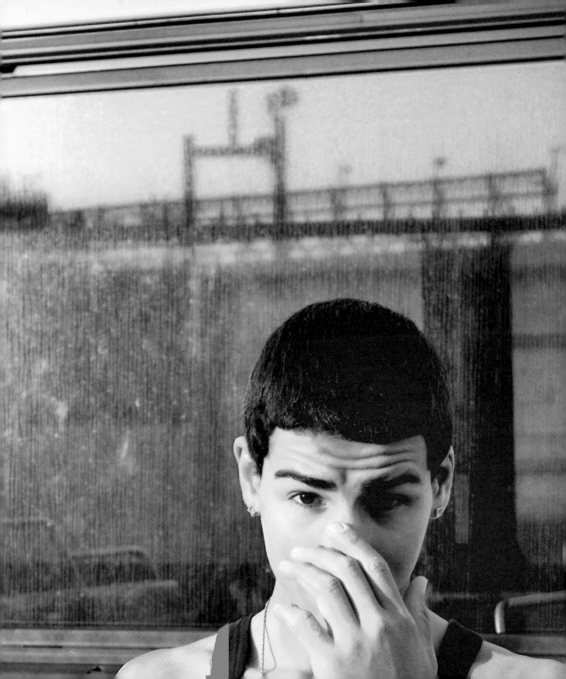

FOR MY SISTER, LISA MARIE

YOU WILL MAKE ALL KINDS OF MISTAKES;
BUT AS LONG AS YOU ARE GENEROUS AND TRUE, AND ALSO FIERCE,
YOU CANNOT HURT THE WORLD OR EVEN SERIOUSLY DISTRESS HER.
SHE WAS MADE TO BE WOOED AND WON BY YOUTH.

—WINSTON CHURCHILL

THE IMPORTANTS
KEVIN AMATO

SAY CHEESE
ALIX BROWNE

AFTERWORD
RICK OWENS

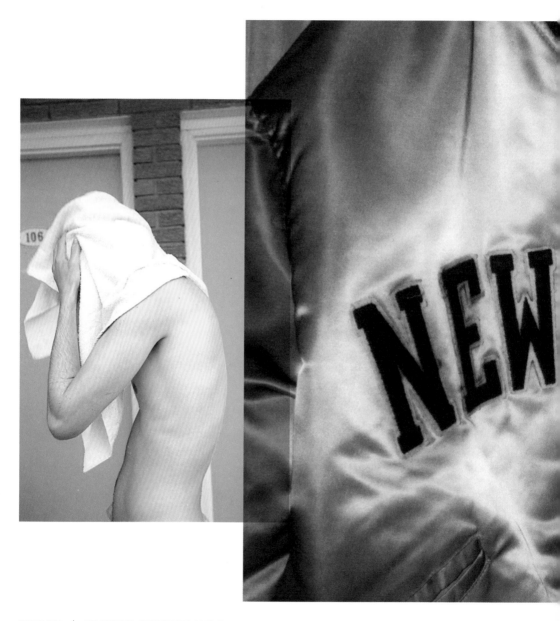

WASHED ★ GRANDPA JOHNNY'S JACKET

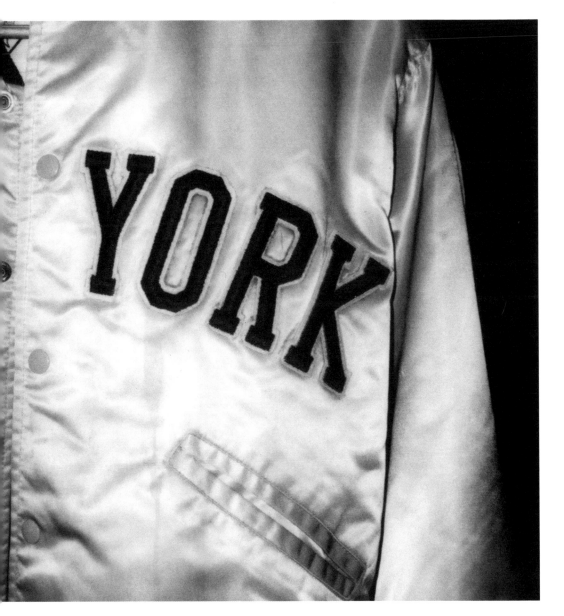

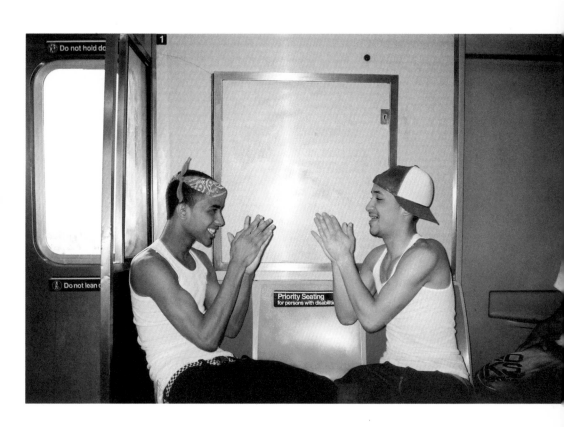

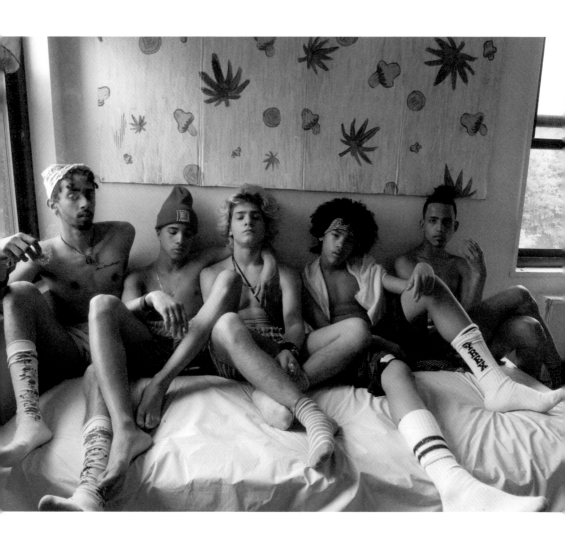

SAY CHEESE ★ ALIX BROWNE

A little more than two decades ago, British *Vogue* published a series of photos of a teenage girl, at home, in her underwear. The surroundings are meager: the walls are bare, the furniture scant and cheap, the bed unmade. The girl is skinny, flat chested, her body almost boyish. The story, which was photographed by Corinne Day and featured a then little-known model named Kate Moss, is now regarded as one of the defining fashion shoots of the 1990s; when it came out, however, it was criticized by one British newspaper as "hideous and tragic," just this side of pornographic, as glamorizing drug use. So imagine the reaction if the girl had been black. Or Puerto Rican. Or both? And what if it turned out that she wasn't a girl at all, but rather a boy who happened to look like a girl, dressed in girl's clothing? Or a girl who was taking hormones in order to become a boy?

★

Kevin Amato has already taken flack for that. A photographer and casting director, not necessarily in that order, Amato champions the fluidity—racial, sexual—that tends to make people uncomfortable. "I'm all about the macho guy with the transgender person on his arm," he says. Amato is not a fashion photographer per se—his pictures are too out there for all but a select few magazines—but he has come to attention on the platform of fashion, largely through his work with the audacious, multihyphenate brand Hood By Air, for whom he has cast runway shows and otherwise set the tone early on both visually and socially. If the clothes Hood By Air puts out are at once masculine and feminine, street and high fashion, hip-hop and punk rock, darkly menacing and extremely beautiful, the men and women who model them on the runway are all that and then some.

★

Amato, who is in his midthirties but skews much younger, grew up on Long Island, in Massapequa. His family is part Italian, part Puerto Rican, part Irish, and basically all Catholic. I do not know his sexual orientation; in speaking with him, that question struck me as being way too uncool to ask. He has a Caesar haircut, a goatee, and a somewhat disconcerting piercing at the base of his throat. He declares, with some amusement, that when he shows up at a respectable place of business, the assumption is that he's there to pick up a package.

He got his first camera, a Pentax K1000, from his older brother, who had pocketed it at a house party on Long Island and, three months later, wrapped it up and put it under the Christmas tree. Soon Amato had his own darkroom—a sink in the basement really ("All you need is a sink"), installed by his uncle, who was a plumber—and was developing his own film.

<div align="center">★</div>

Scene after scene, Amato wanted to be a part of everything. A camera, he quickly figured out, was a way in. It didn't matter if he couldn't skate, or play guitar. He could take pictures of the skater kids; as a "photographer" (though I am fairly certain he never would have used that term in reference to himself at the time), he could hang with the band. "I thought photography was nerdy at first, but I was determined to make it cool," he says. "It was like the default. And that's what it was to me. It was all documentation. And that's what it is today. Just documentation."

<div align="center">★</div>

Amato's current turf—his home and his subject matter both—is the Bronx, probably the least-loved borough of New York City, but one that comes across in his photos as he describes it: "pure, uninhibited, and overlooked. Preserved by generations of culture and family tradition. Timeless and tribal." And if by documentation he means honest, uncontrived, occasionally candid, then I suppose yes, his photos qualify as such. Amato doesn't like to give his subjects a lot of direction, though he admits to maneuvering them into nicer light from time to time; he prefers, when on assignment for a magazine or a clothing brand, to be set up with a bag of clothes rather than with a stylist. He does not work with an entourage. Trust and access, he likes to say, are his f-stop. His technical. The results are intimate rather than distant, often touching or funny, weirdly wholesome, and notably lacking a sense of crucial, unflinching objectivity. Amato is not out to shock or provoke, merely to get us to see what he sees, how he sees it.

<div align="center">★</div>

The machismo of thug culture is thoroughly disarmed. In one photo, a rapper cuddles a puppy. In another, a tough-looking character stands

on a beach, his full-frontal swagger gently undermined by the pit bull he holds up to himself as if it were a dress. Within this context, a shot of a plate of Italian cookies can suddenly seem oddly revealing. Amato's intentions are writ large, on the index finger of his right hand, which is tattooed with the words SAY CHEESE. "I invite people in," Amato declares, making no distinction as to whether he is talking about his apartment, his photographs, or his life.

<div align="center">★</div>

His first book of photographs, which he self-published in 2015, in a limited edition of five hundred copies, is titled *Cozy*, which to him means "being content ... good vibes ... being so comfortable that you just don't give a fuck much"—and which would seem to apply equally to the photographer as to the people he brings into focus. There are needles, pussies, and dicks, one review noted, comparing his work to that of photographers such as Larry Clark or Terry Richardson or Ryan McGinley—but wrapped in warm blankets. "Because I make it feel comfy, I guess," Amato says. "It was the craziest thing I ever read but it kind of made sense. I don't censor myself. It's by choice. There are ways to get a point across without cursing."

<div align="center">★</div>

And it's true that in his day-to-day life, walking around the circus that is his neighborhood (his word, not mine), Amato inevitably sees way more than he shoots. Though it hurts sometimes, he can, he says, relinquish. Weed, sex. Okay. Guns, not okay. Indeed, the photographer ultimately upholds a value system many would accuse him of blatantly subverting. If there is a surprising lack of nudity in this book, it's out of recognition of the younger fans who showed up to the signings for *Cozy*. "I made a decision that I wanted to speak to everyone."

<div align="center">★</div>

The official casting arm of Amato's operation is the Mother Division, but Amato also accepts model submissions through his website on a page that announces emphatically, "BE A MODEL!" in what may or may not be a wink to the Barbizon modeling school ads from the 1970s, minus the tagline ("or ... just look like one"). Here the conventions of beauty have

no currency. The ask is for photos that are specifically "candid, non pro, natural preferred." In other words, like the ones Amato takes himself.

<center>★</center>

A "mother agent," in industry-speak, is someone whose mission is to discover new models and build their careers from the street up. Having an agency might be considered somewhat self-serving in light of the fact that Amato, given a choice, will always prefer to photograph people he casts himself. Maybe as a point of pride, maybe as a point of distinction. But with Mother, Amato is not assembling a roster so much as a family, and it's a responsibility he doesn't wear lightly. "I tell the kids, modeling is not a career; it's something you can make a career out of. A transgender person has more needs, more expenses. It's not like getting a haircut. Fashion may celebrate it now, but we'll see what happens. Someone like me would always accept them. I'll be their fallback plan."

<center>★</center>

Twenty years from now, we may look back and realize that a portrait of a scrawny kid dressed in a pink poodle T-shirt, a black lace knee-length skirt, frilly ankle socks, and Nikes was among the defining fashion images of our time. Amato would probably find that amusing. "I don't know shit about fashion," he says. "Fashion is now what we make it. The one thing that being in the Bronx has taught me is that people are all the same at the end of the day. We're unique in our own ways, but regardless of race, social class, sexual orientation, gender, we all just want to be recognized and respected."

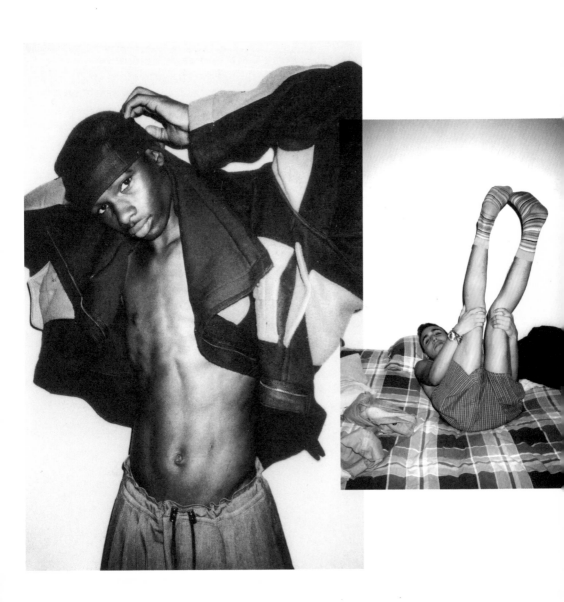

SALIEU ★ SOCK BOY ★ YOUNG AMERICAN

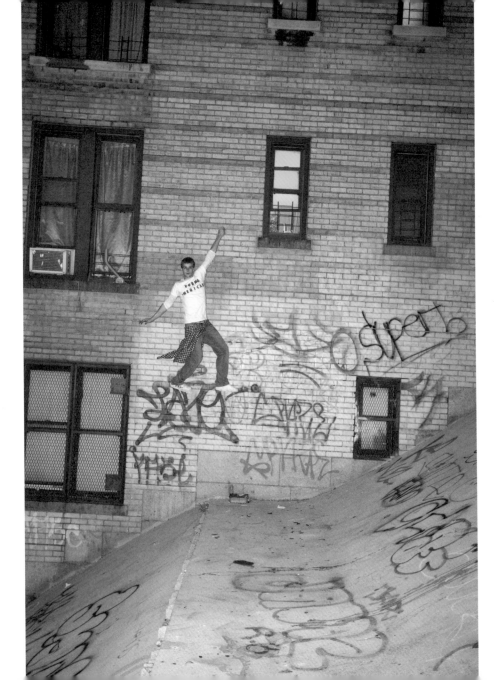

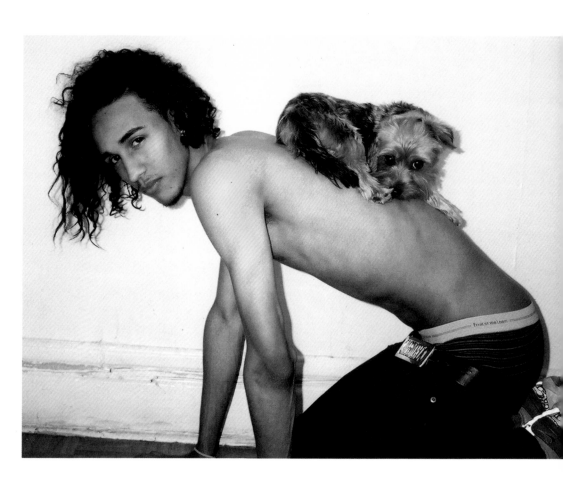

MELLO + DOG ★ EMMA

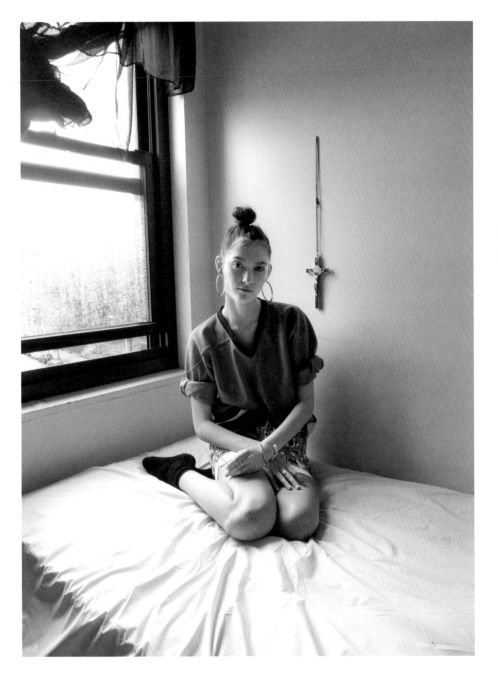

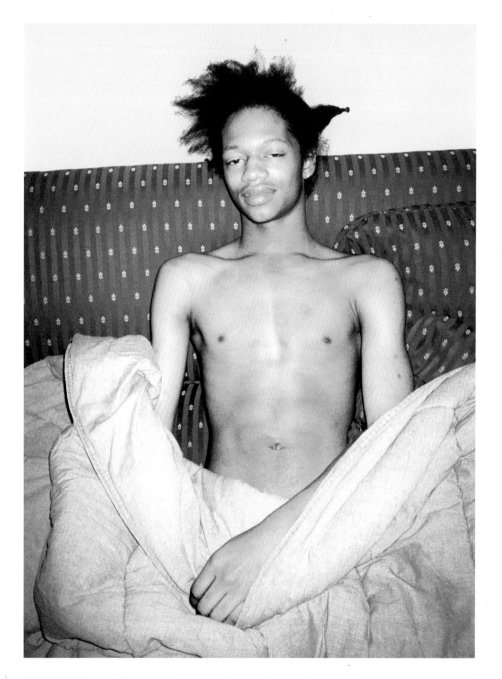

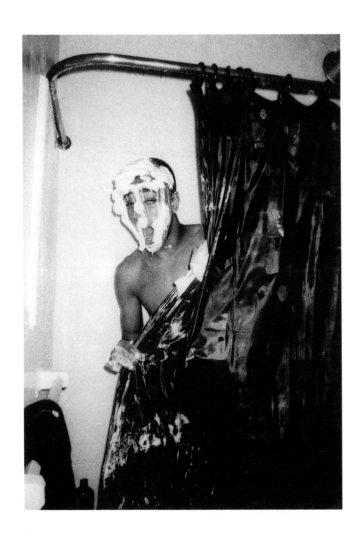

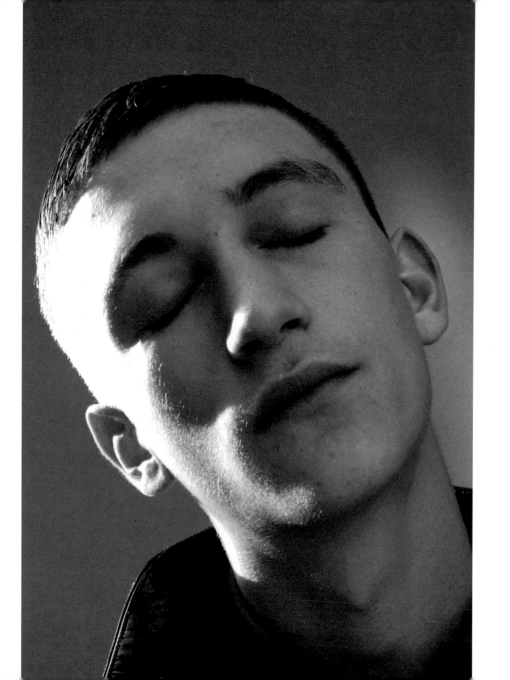

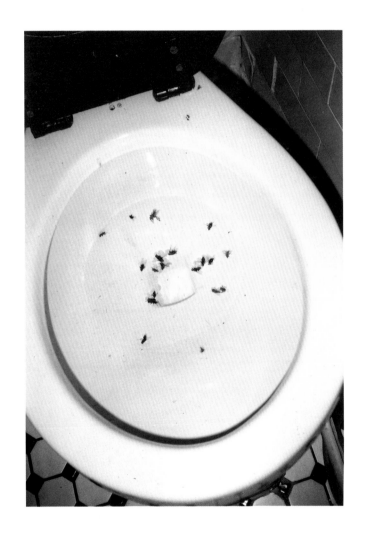

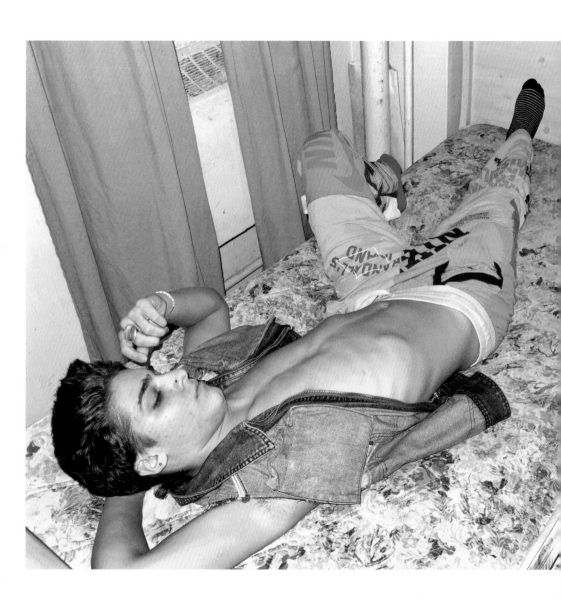

ABDUL ★ NOO DICE

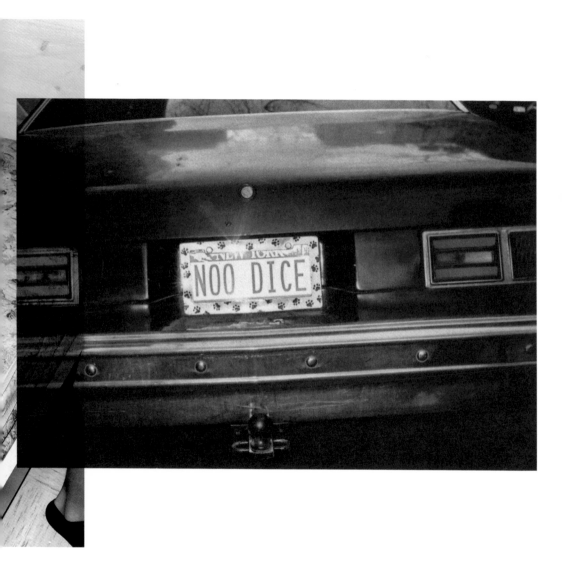

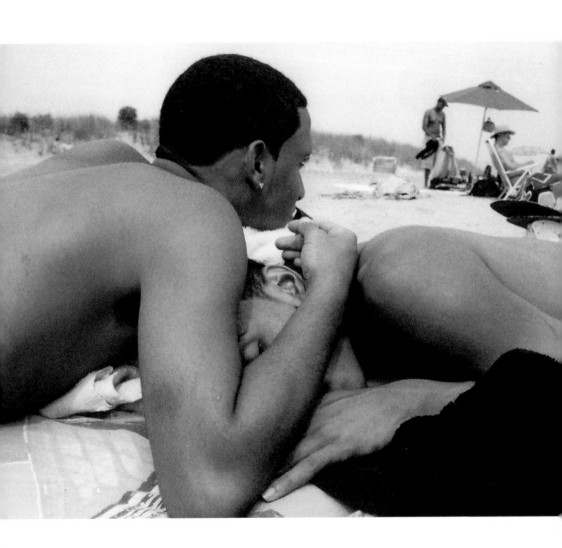

EMBRACE ★ DESTINY

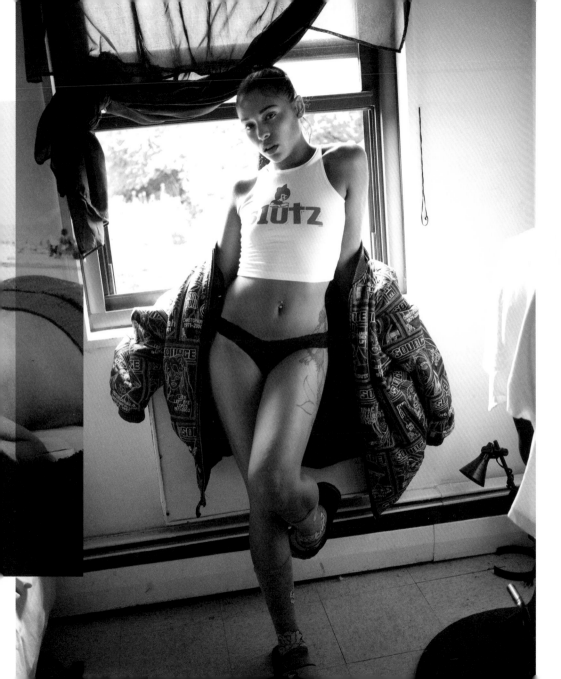

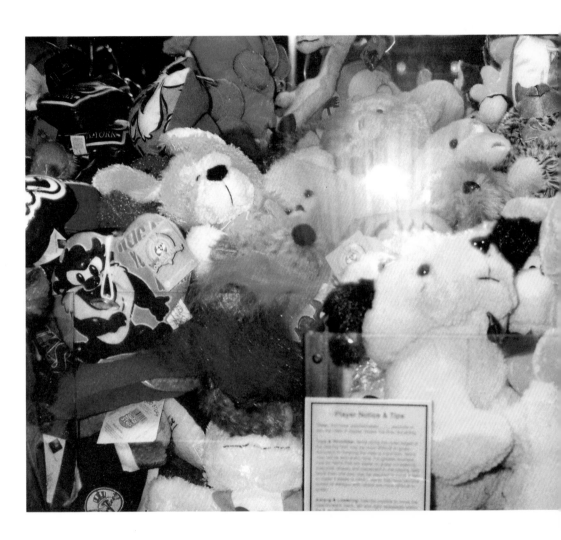

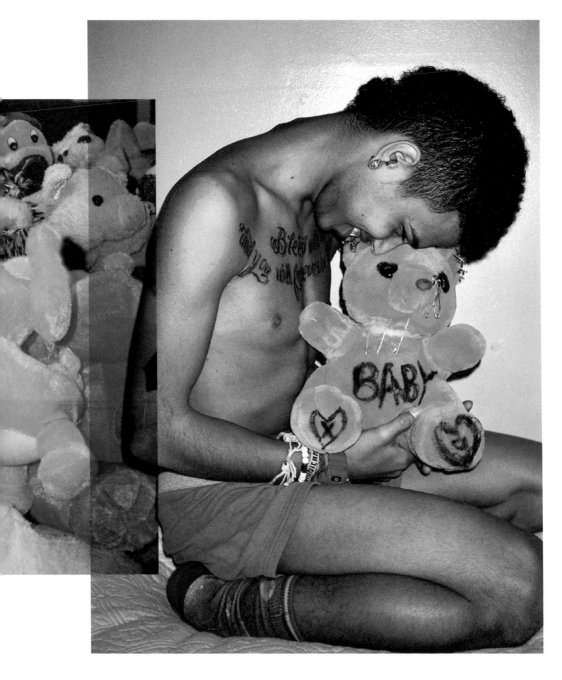

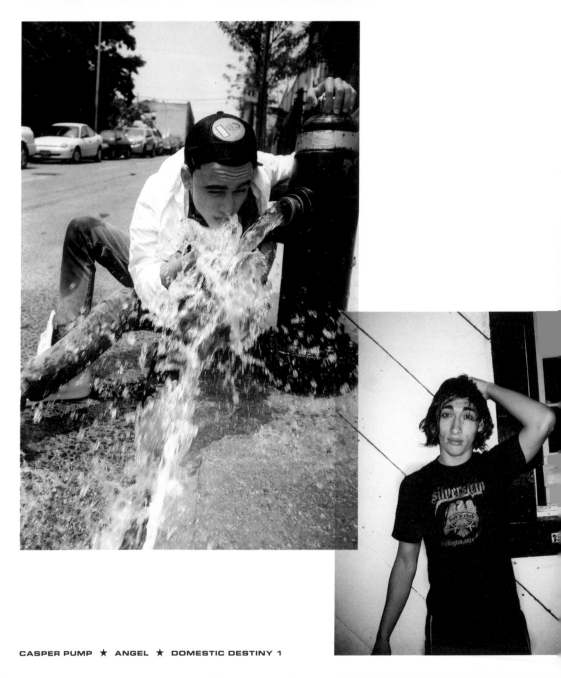

CASPER PUMP ★ ANGEL ★ DOMESTIC DESTINY 1

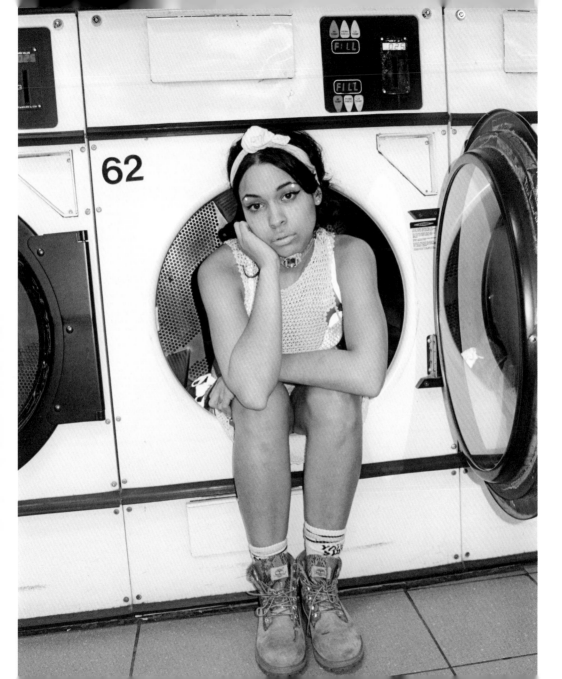

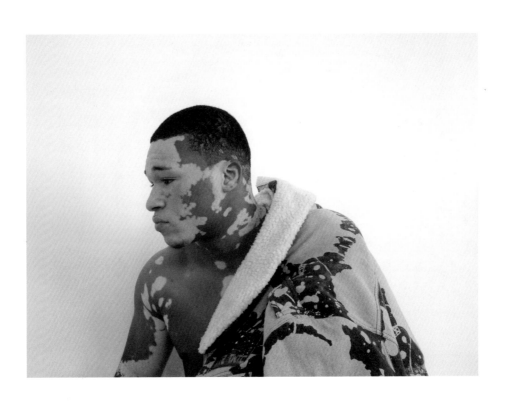

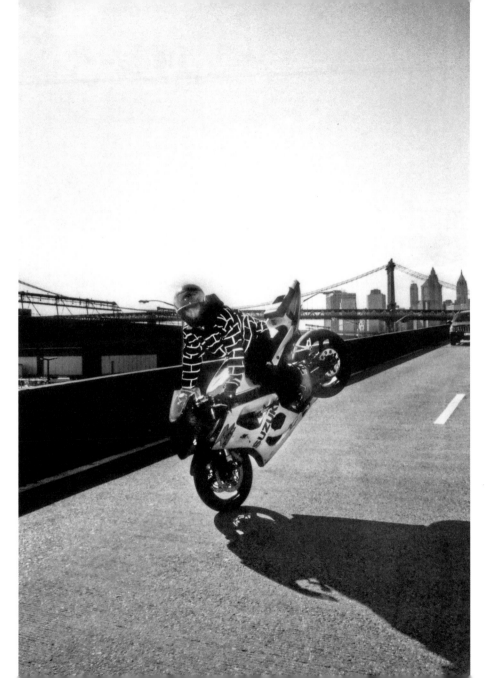

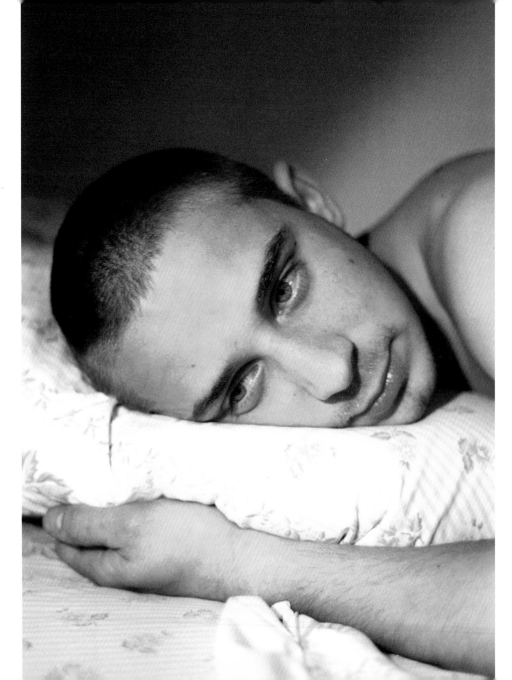

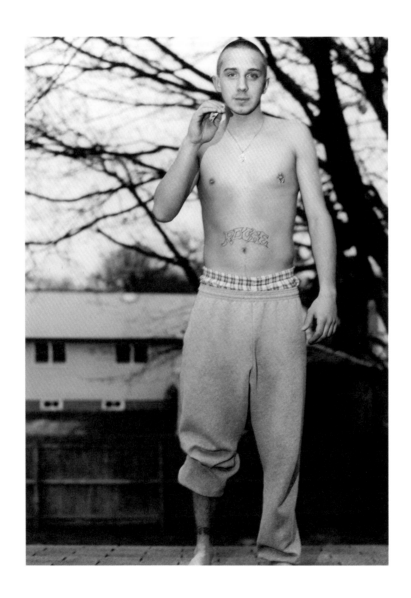

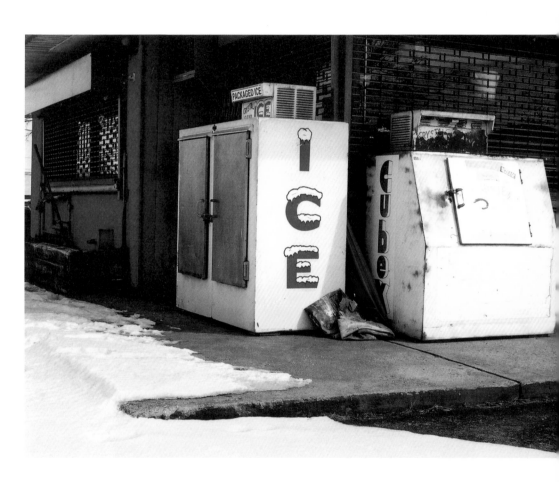

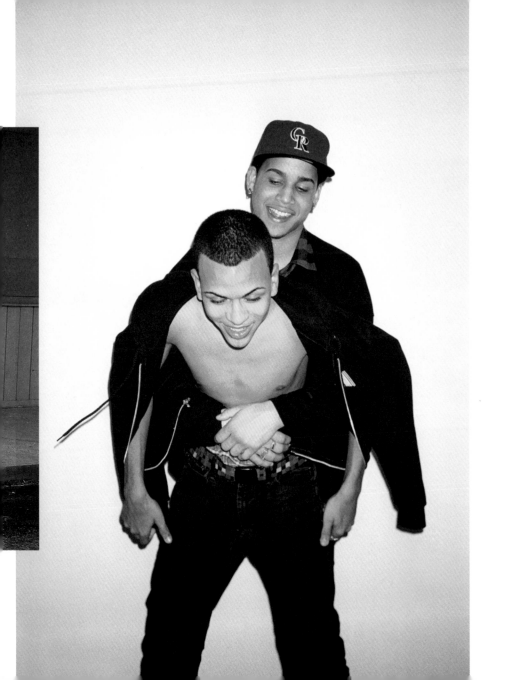

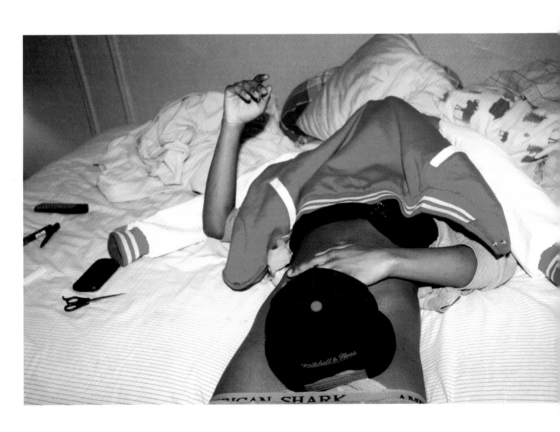

AMERICAN SHARK ★ JIMMY SMOKE

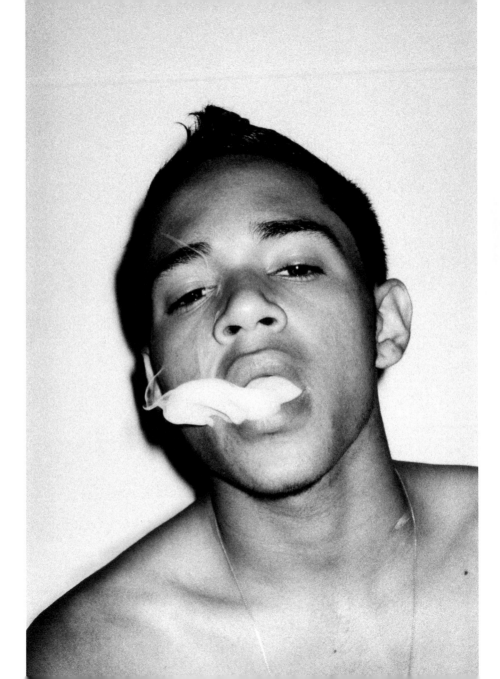

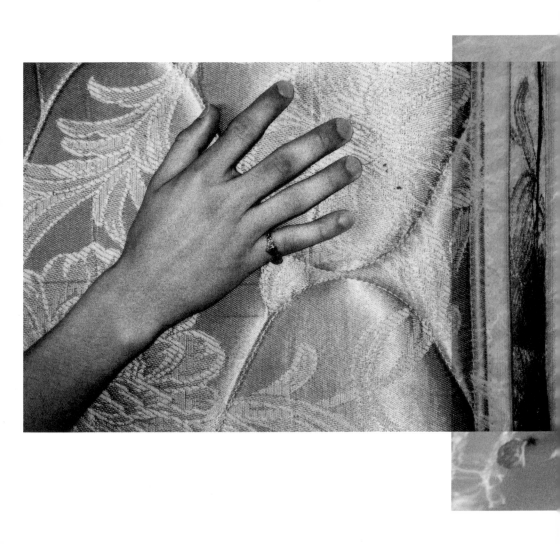

DOUBLE HEART RING ★ DEADFLOAT

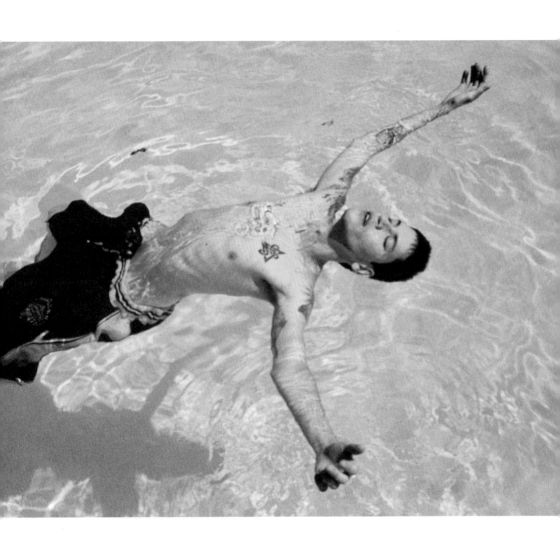

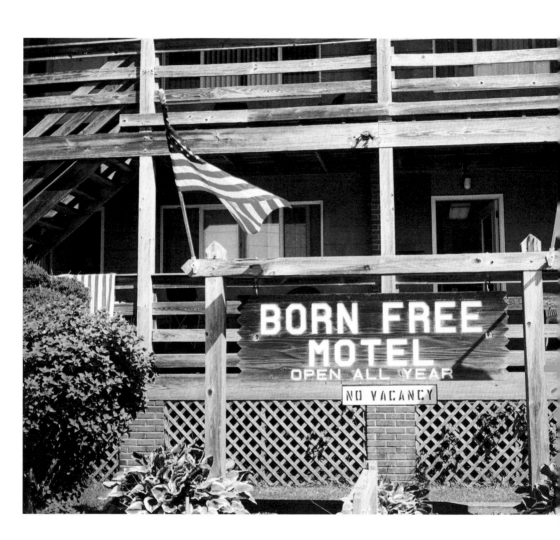

BORN FREE / NO VACANCY ★ MAGGIE

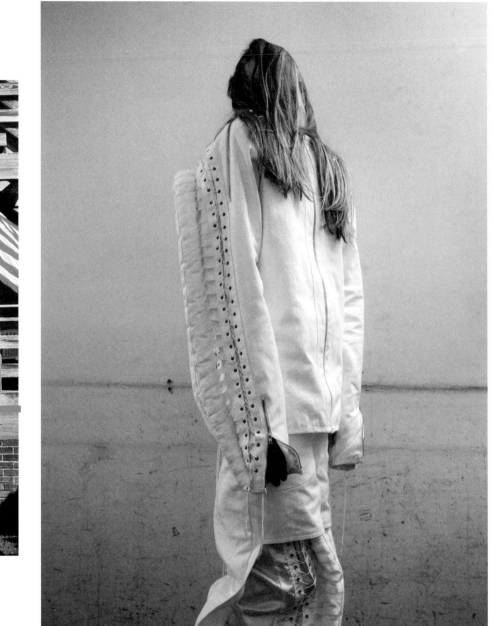

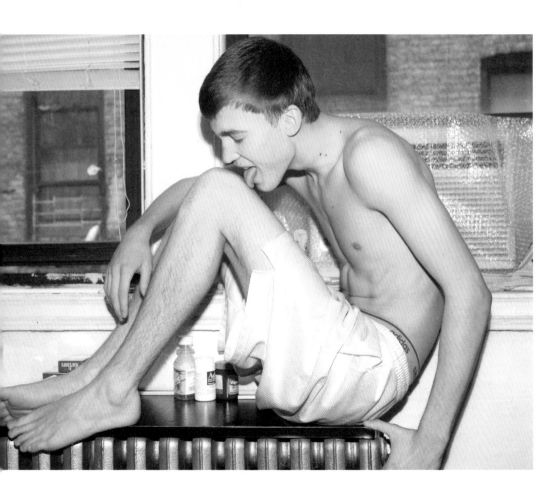

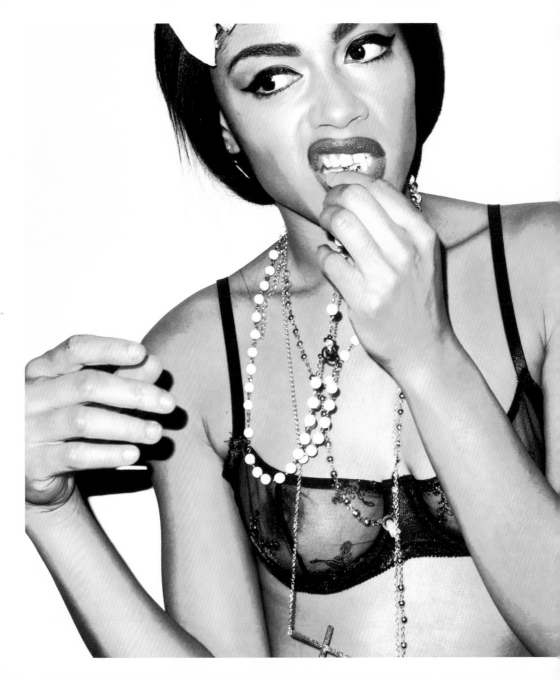

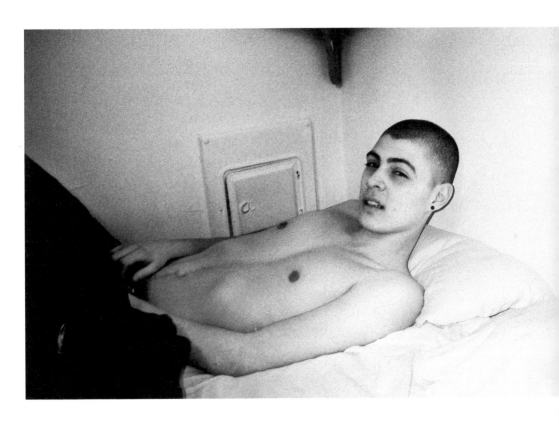

MICKY HOME

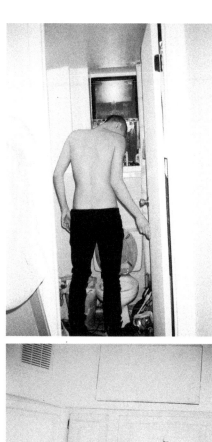

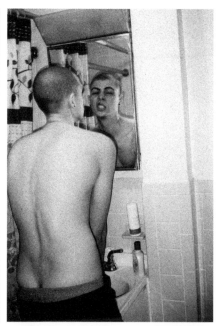

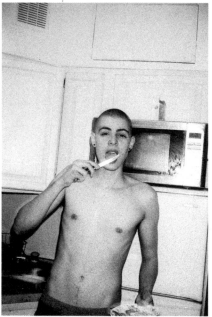

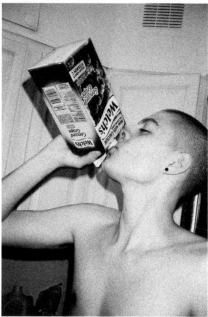

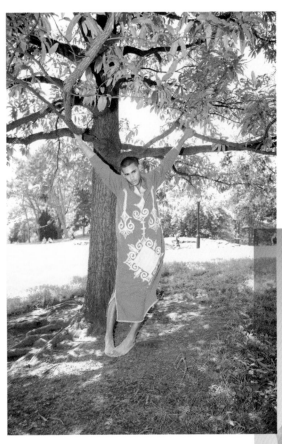
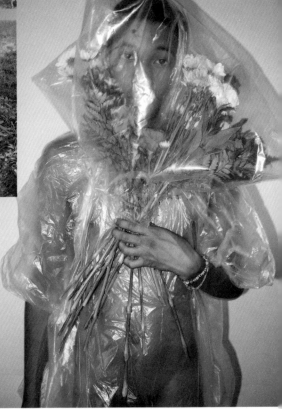

CHRISTIAN ★ FLOWER BOY 1 + 2

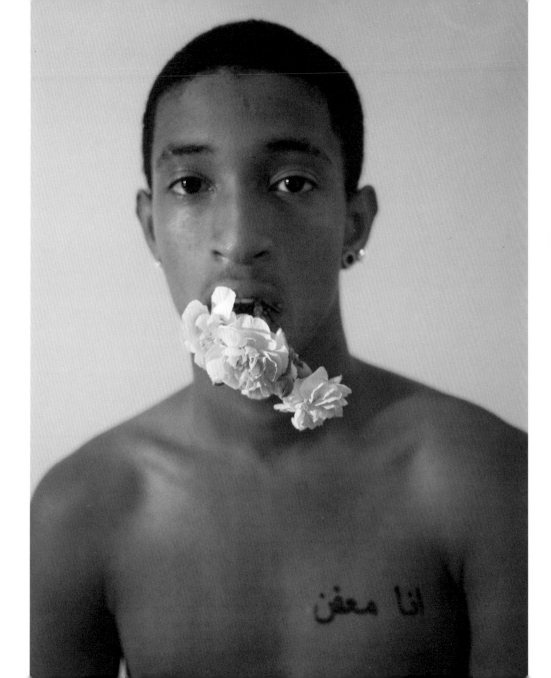

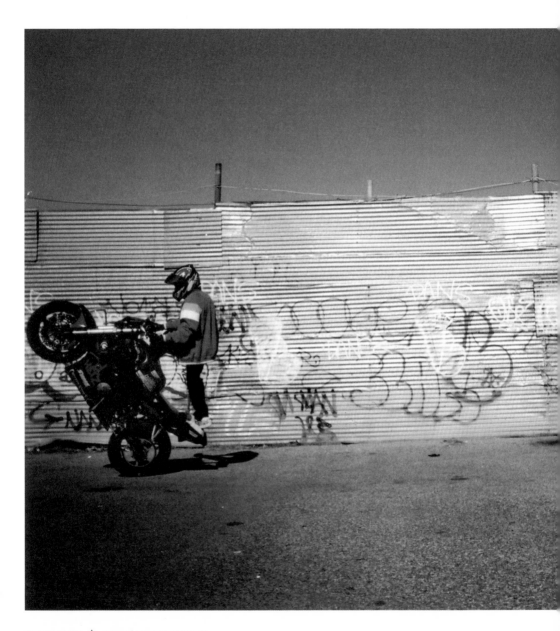

TRICK BIKE ★ CHAD SPAGHETTIOS

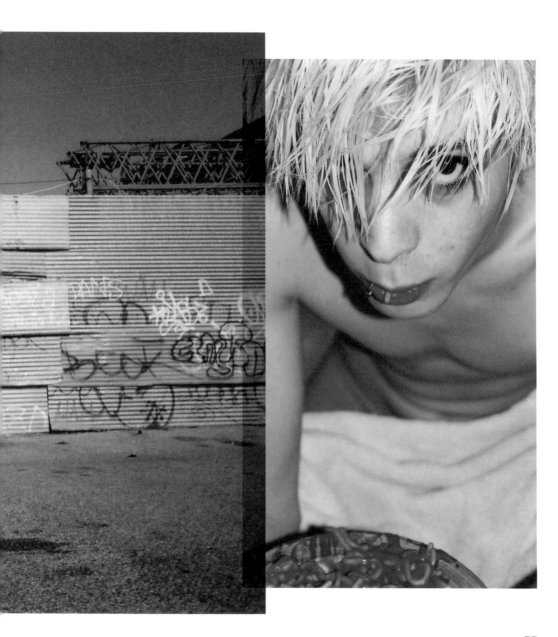

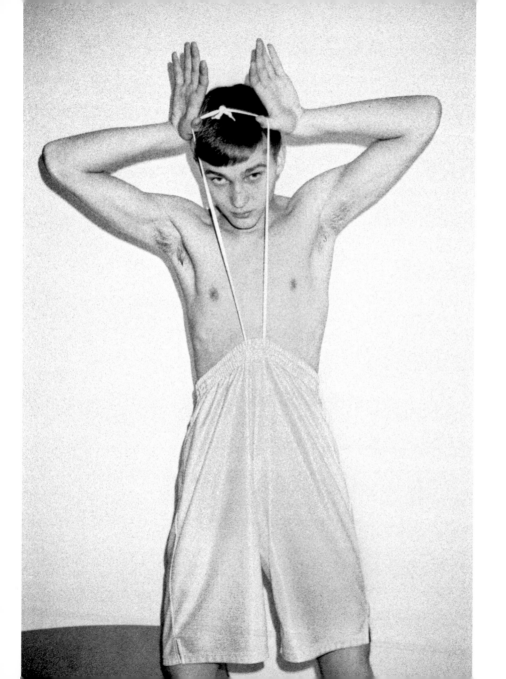

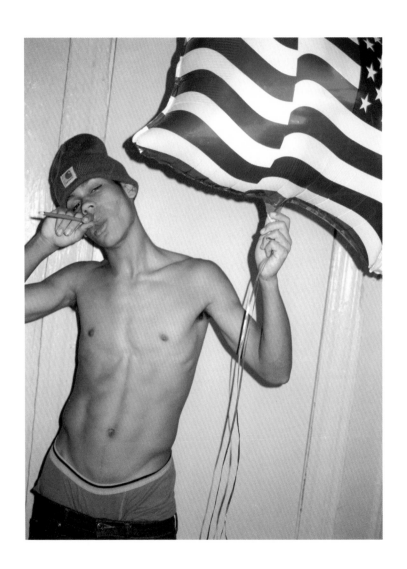

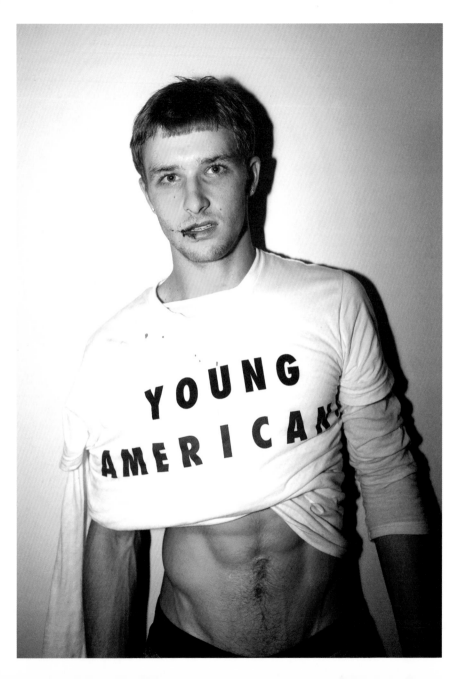

YOUNG AMERIC
★
DOMESTIC
DESTINY 2

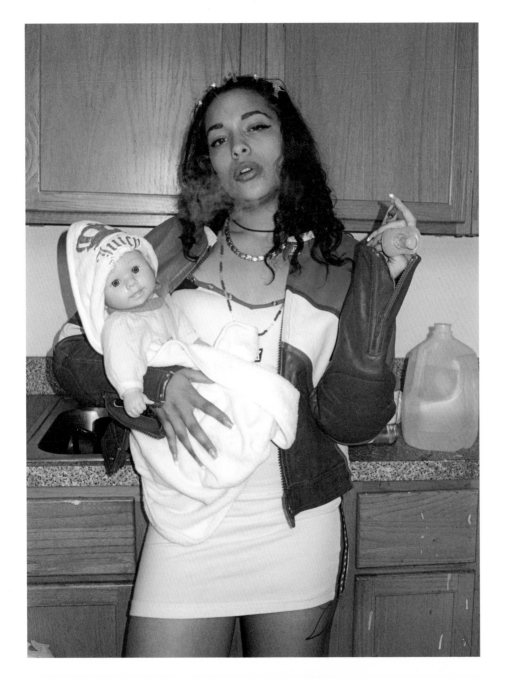

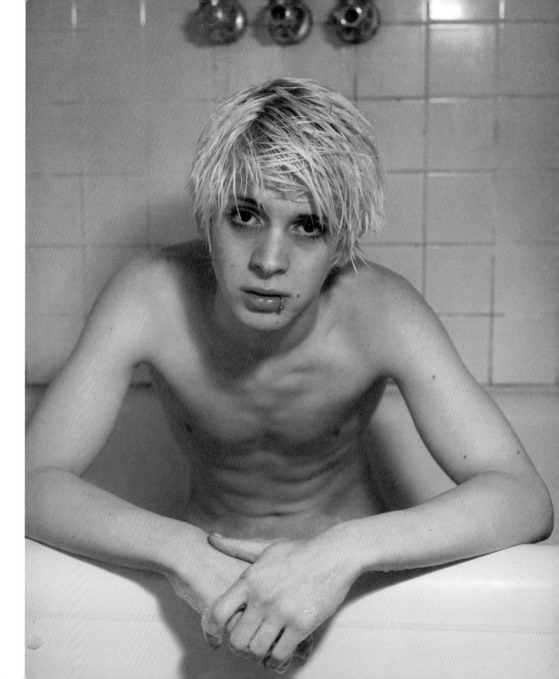

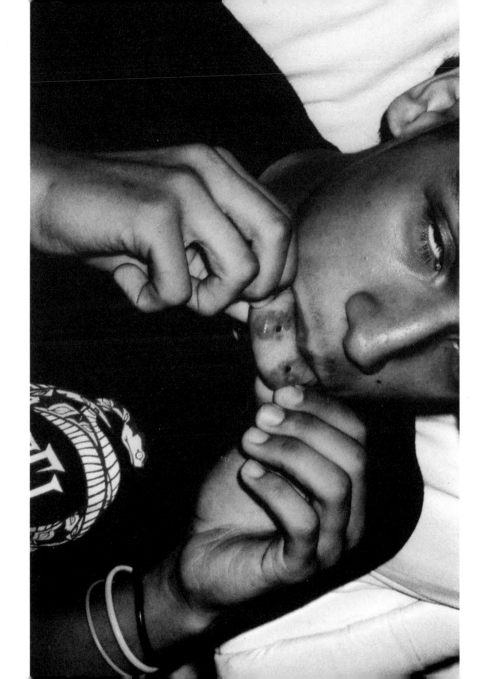

MAD TUB

SNAKE BITES

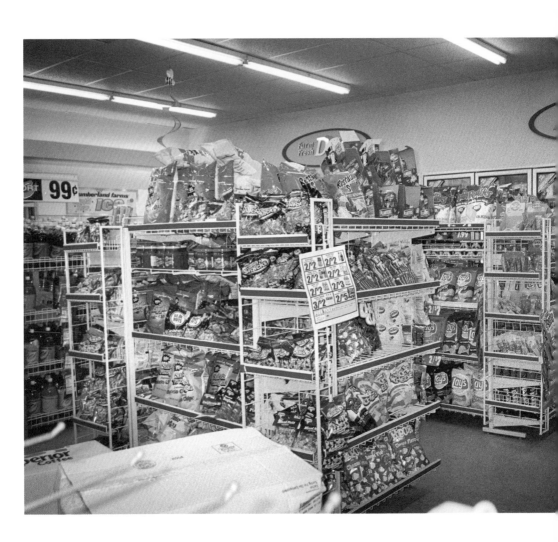

99 CENT (HOMAGE TO A. GURSKY) ★ PREGGERS

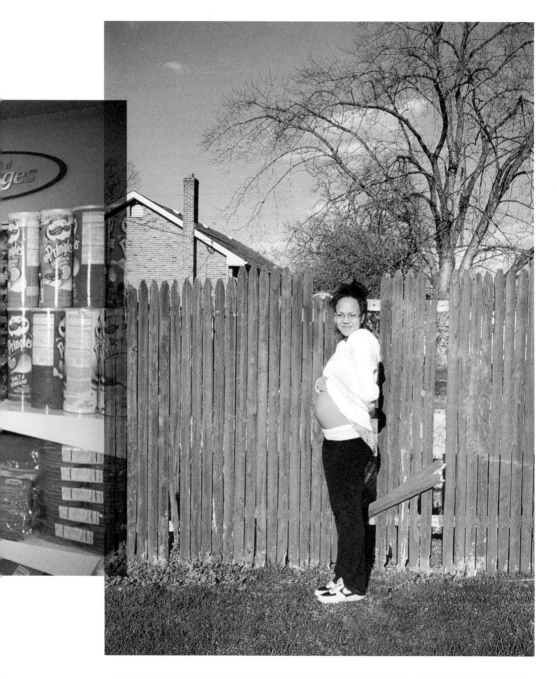

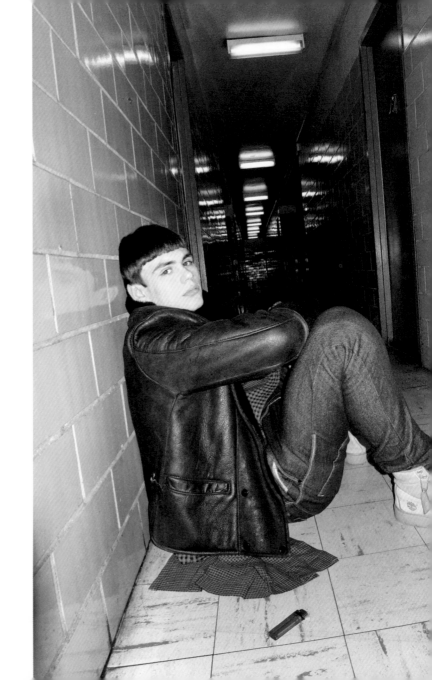

MATTY BOY
★
MALUCA MALA

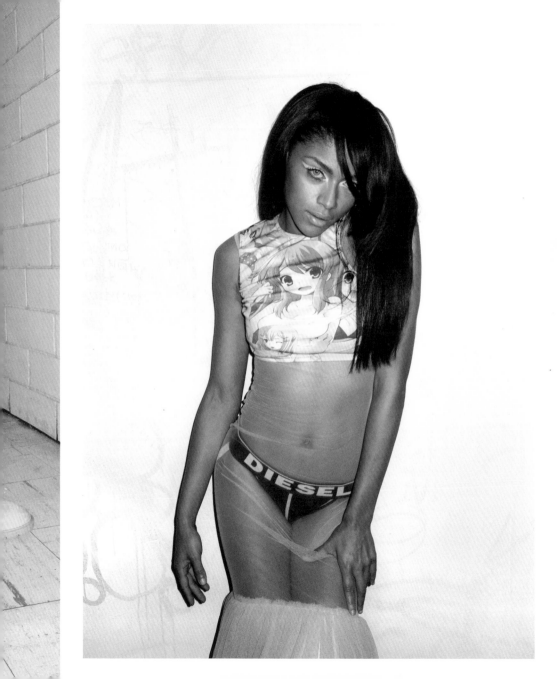

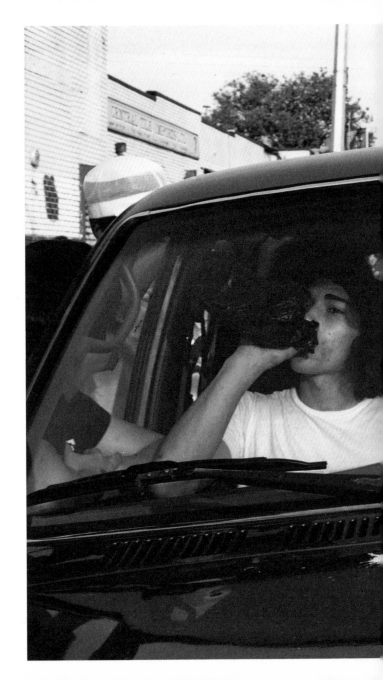

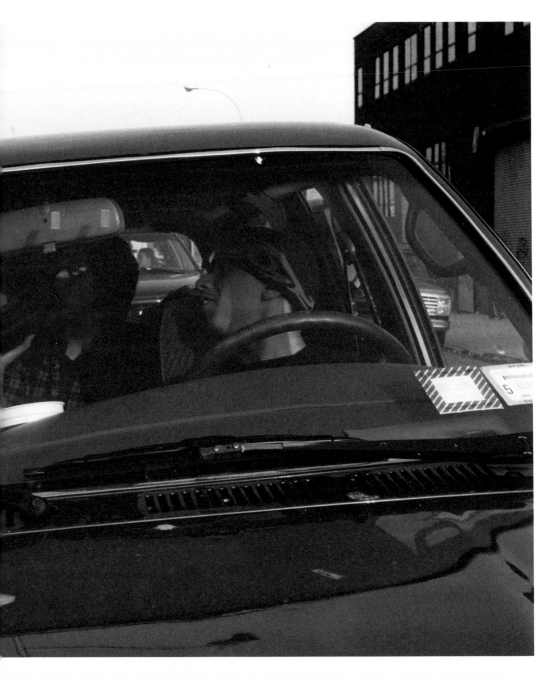

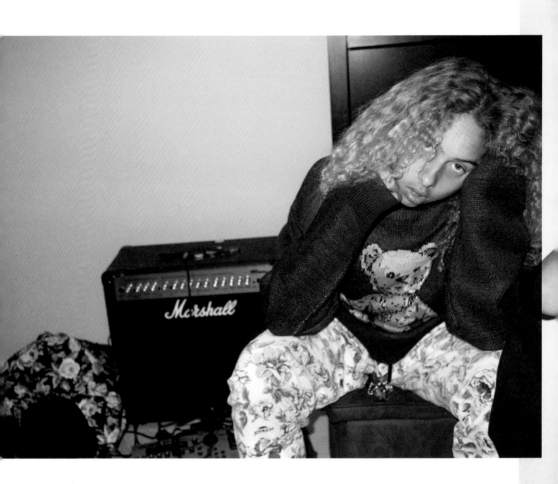

OLAN, LA ★ MONKEYFACE ★ LUKA'S UP

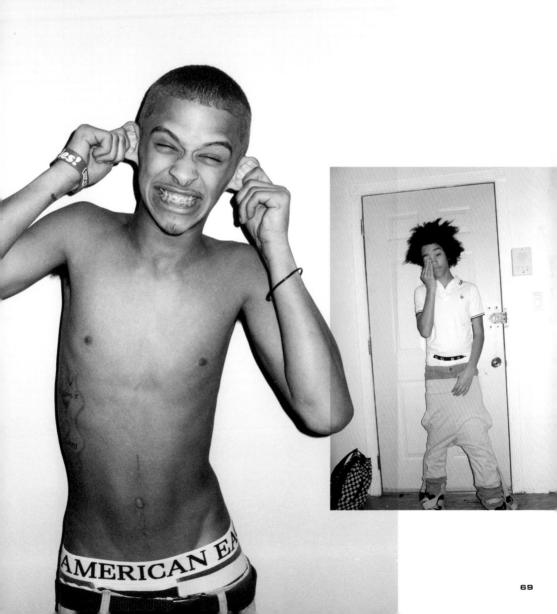

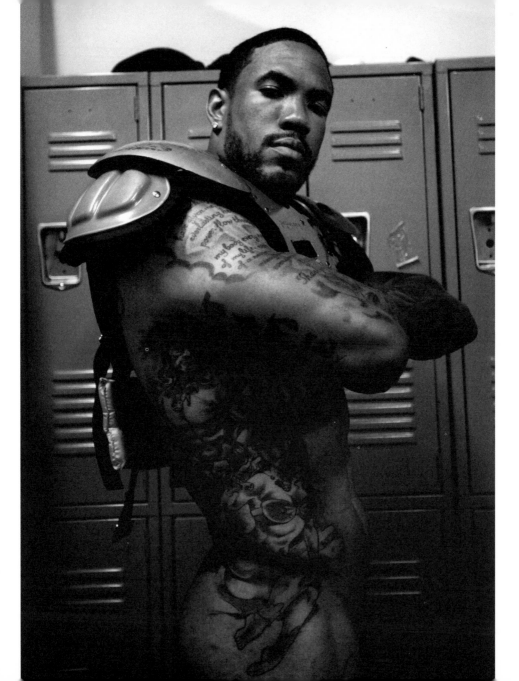

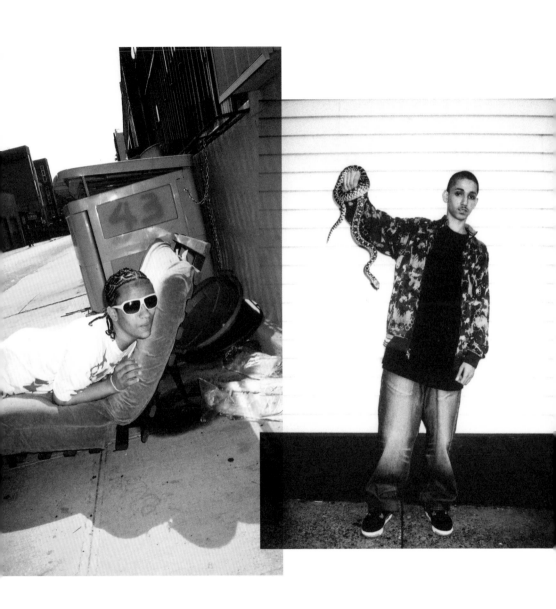

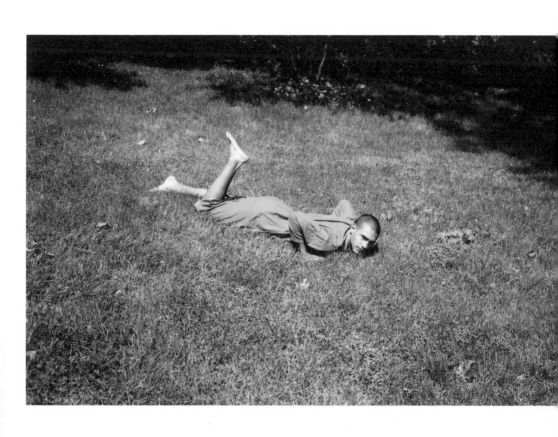

CHRISTIAN ROLLING HILLS ★ MASQUERADE TRADE

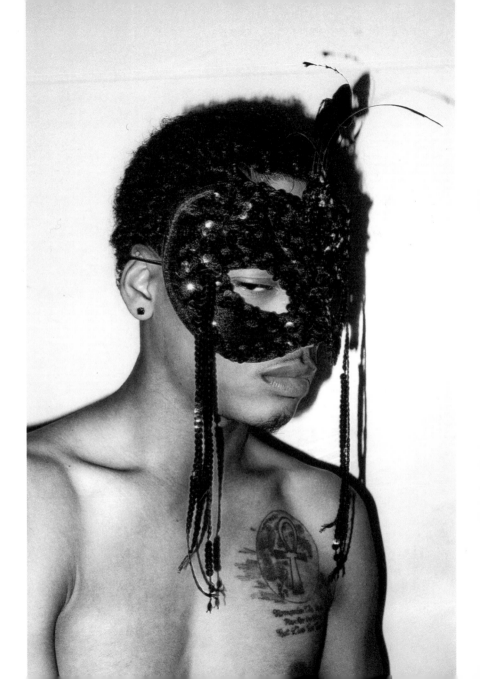

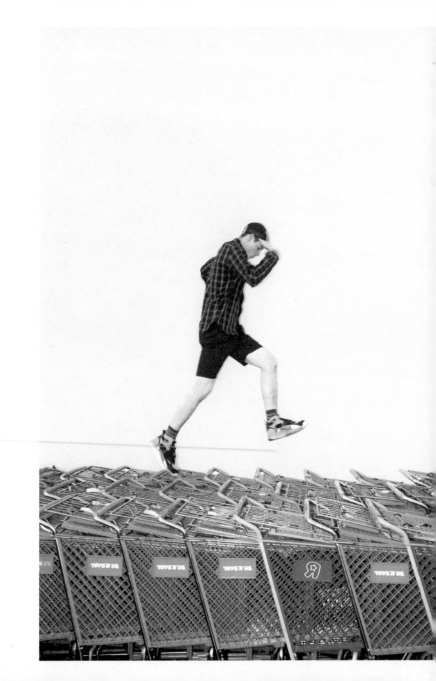

SHOPPING CART
★
HALEY

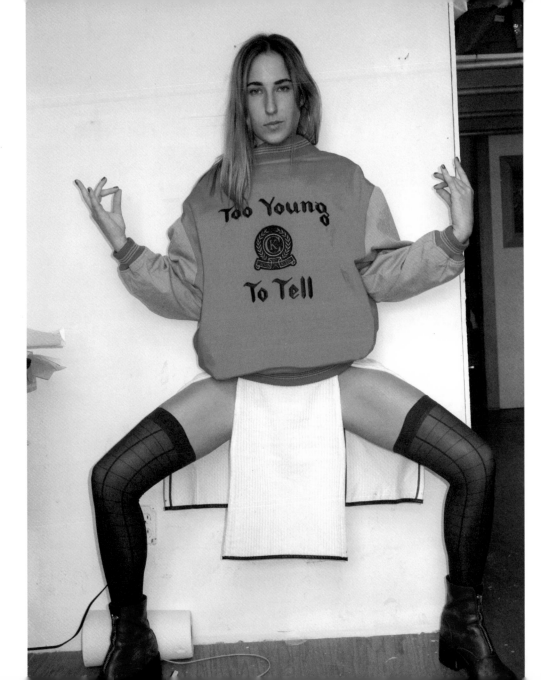

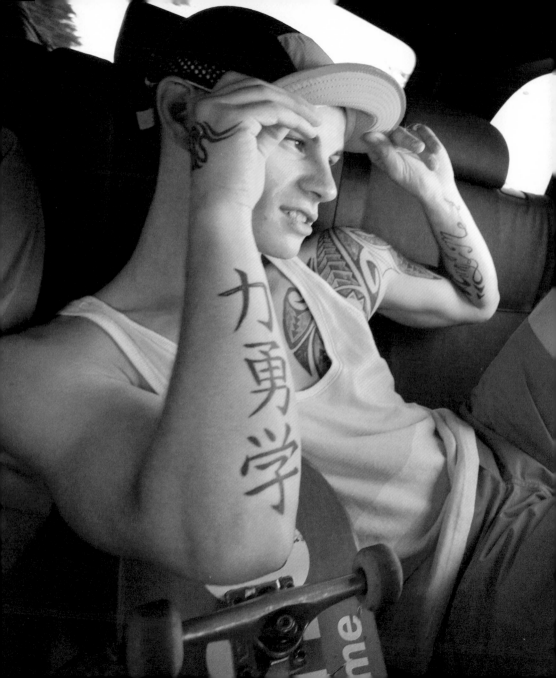

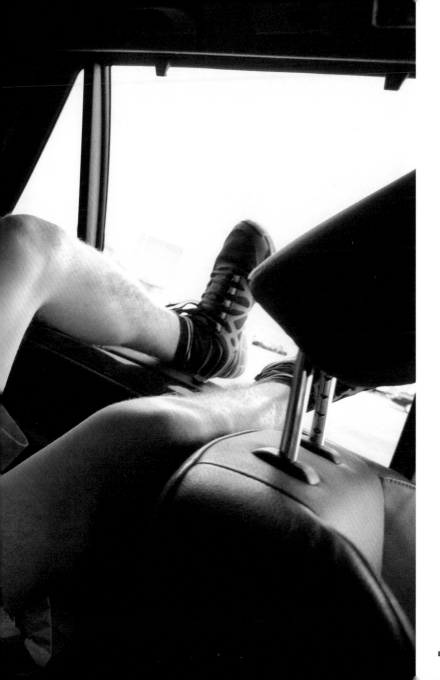

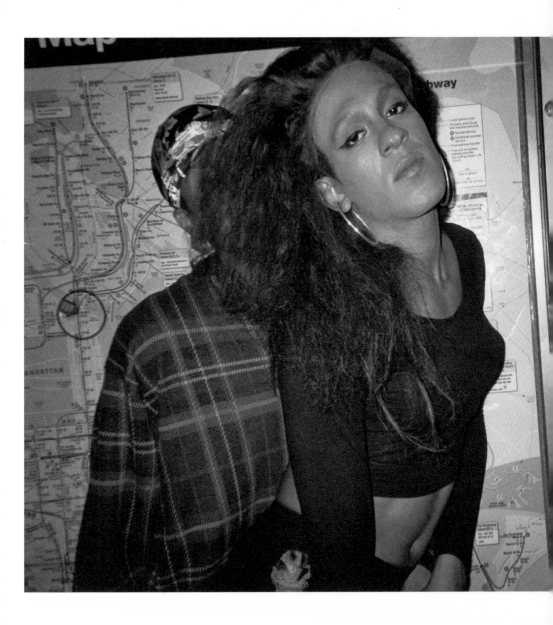

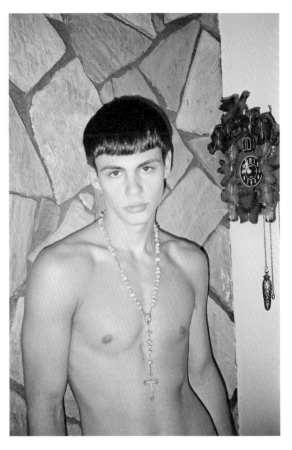

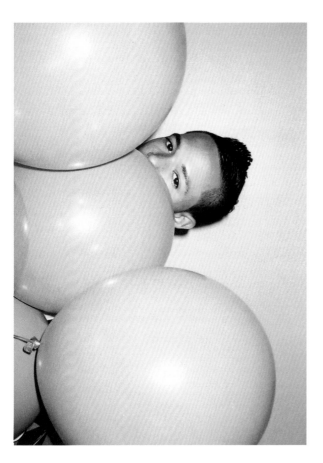

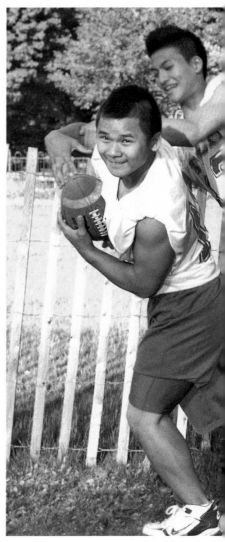

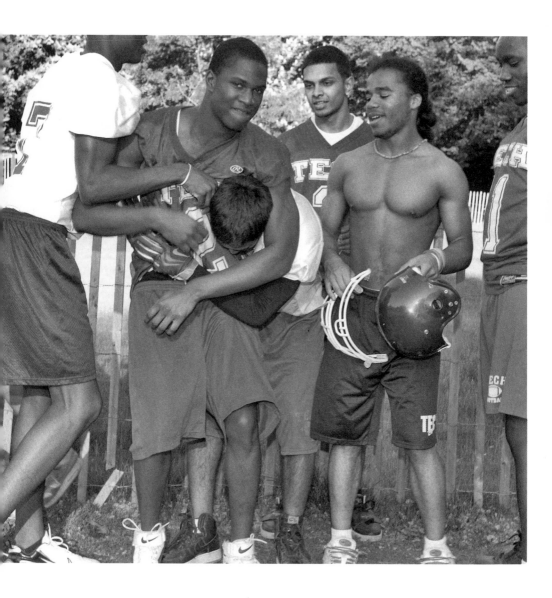

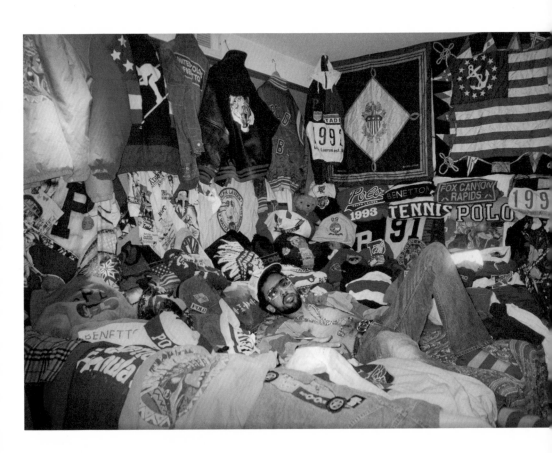

TAZ ARNOLD ★ PRINCE

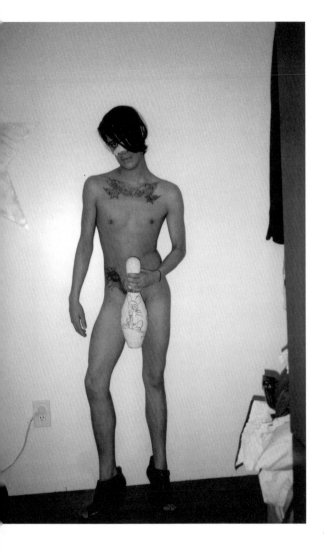
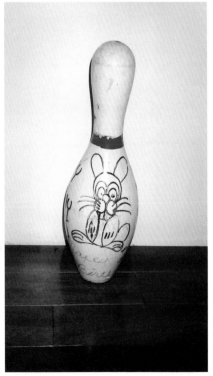

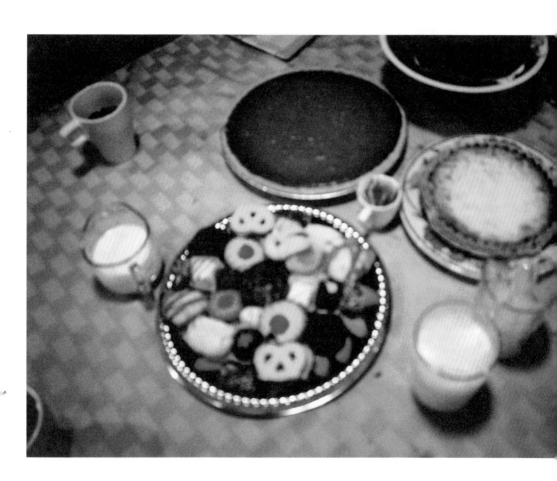

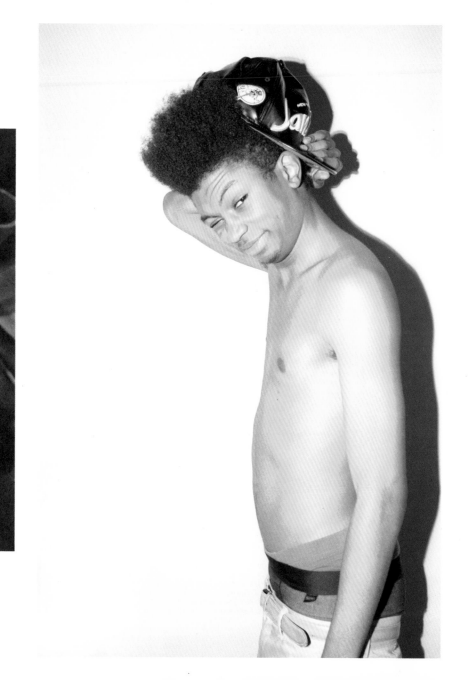

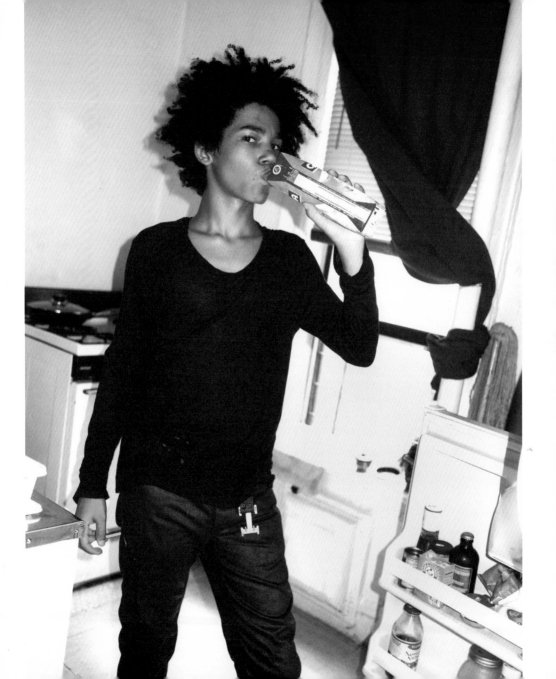

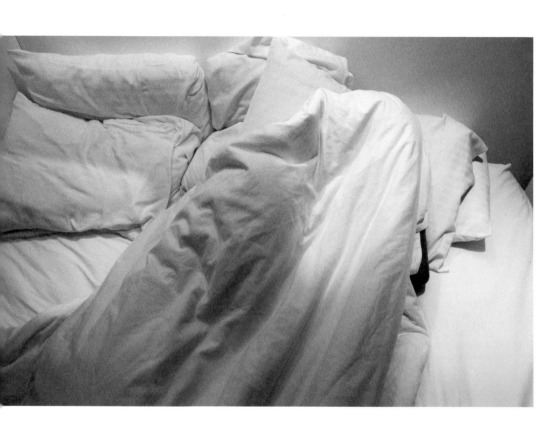

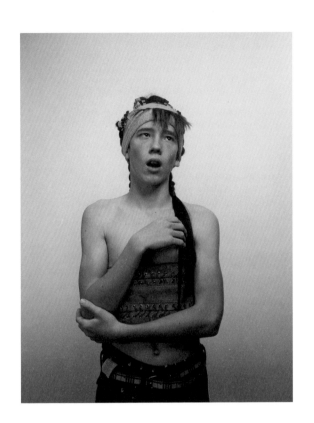

SAINT JACKSON ★ LIPZ WINDOW

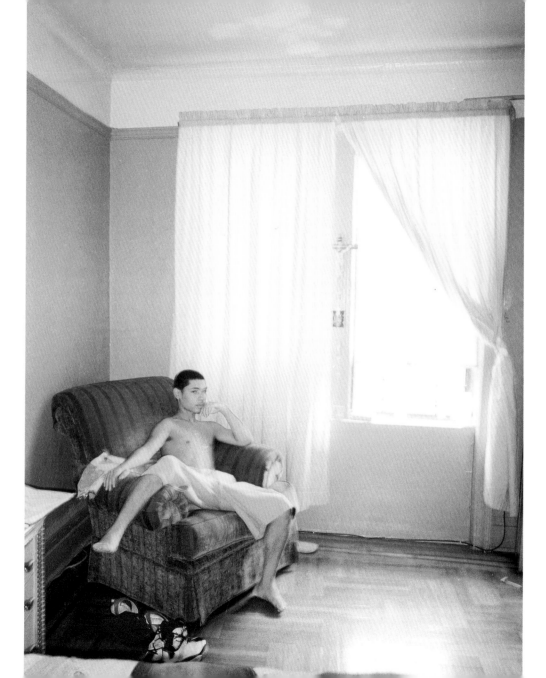

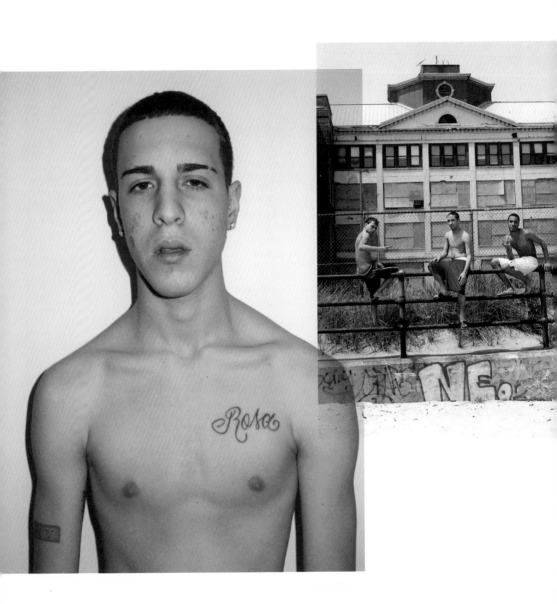

LUIS ★ ROCKAWAYS ★ CONTRAPTION DOG

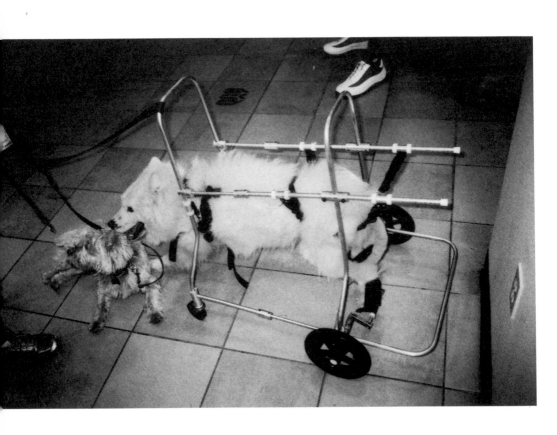

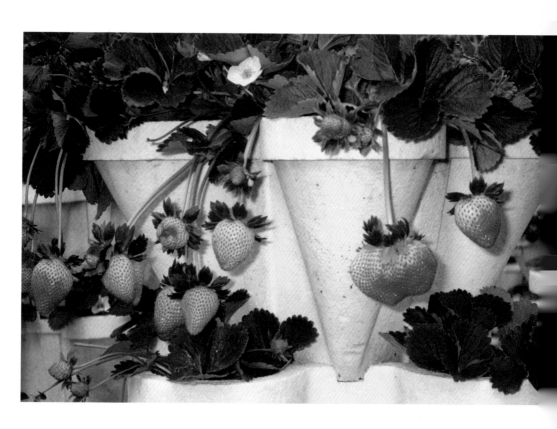

HYDROPONIC STRAWBERRIES ★ CHRIS BROWN

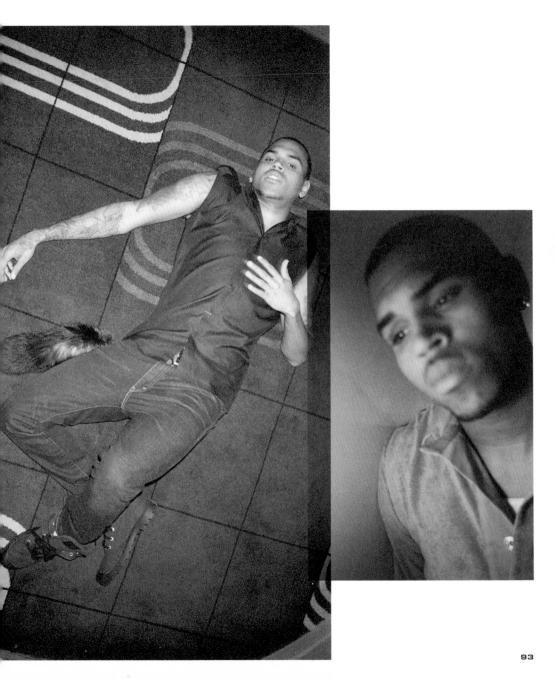

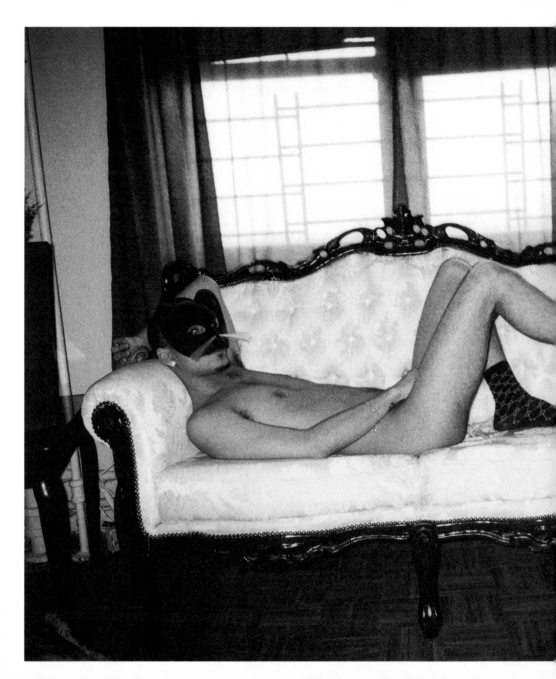

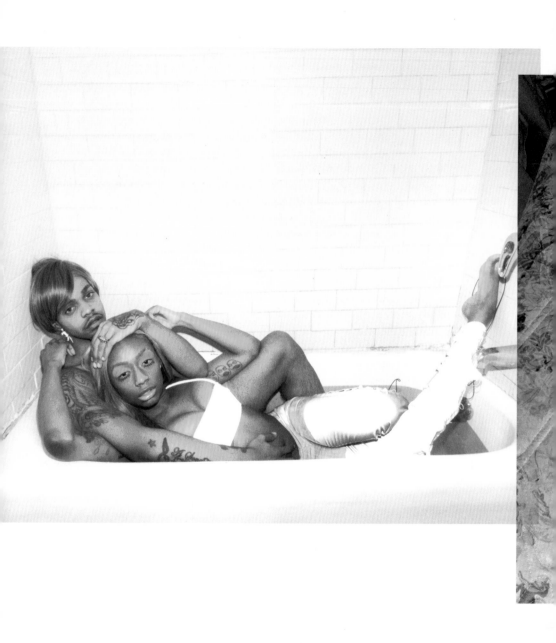

IAN ISIAH + JUNGLEPUSSY BATH ★ CHICKEN MATTRESS

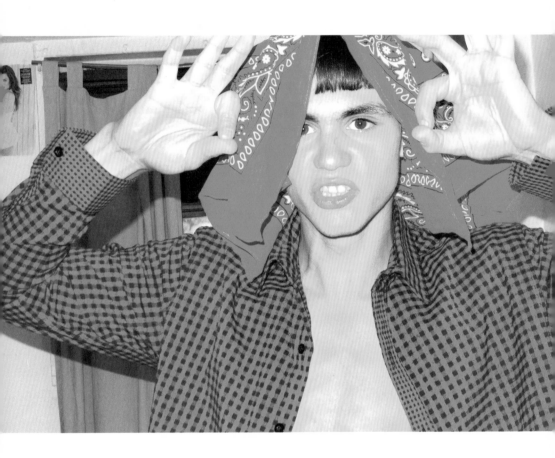

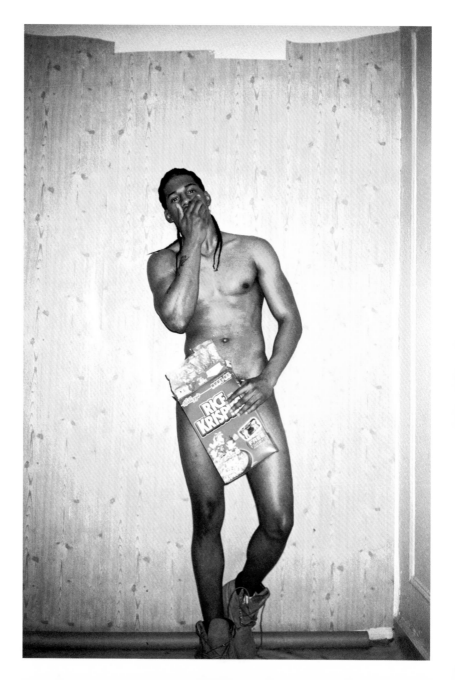

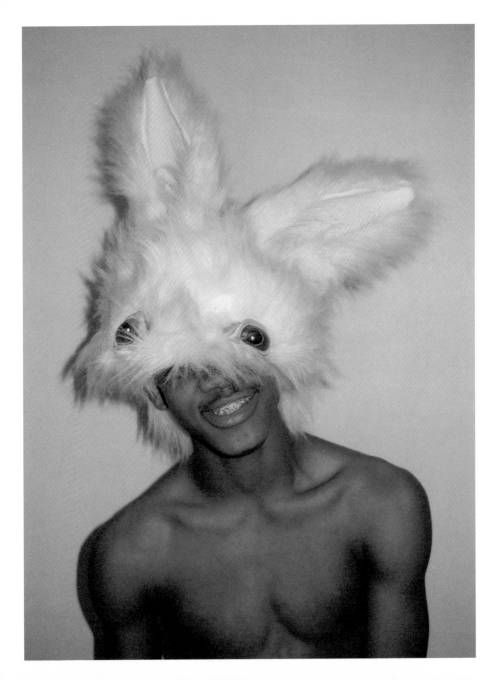

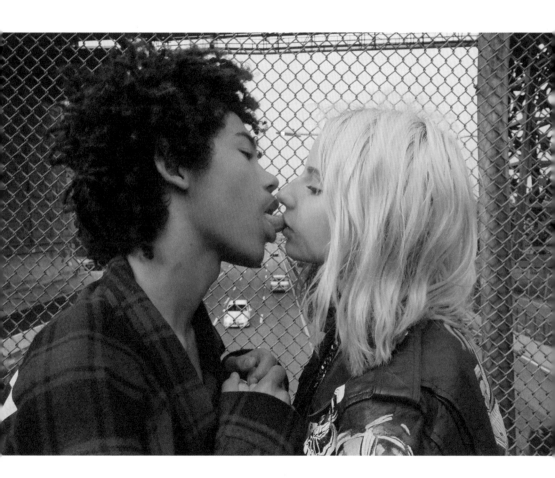

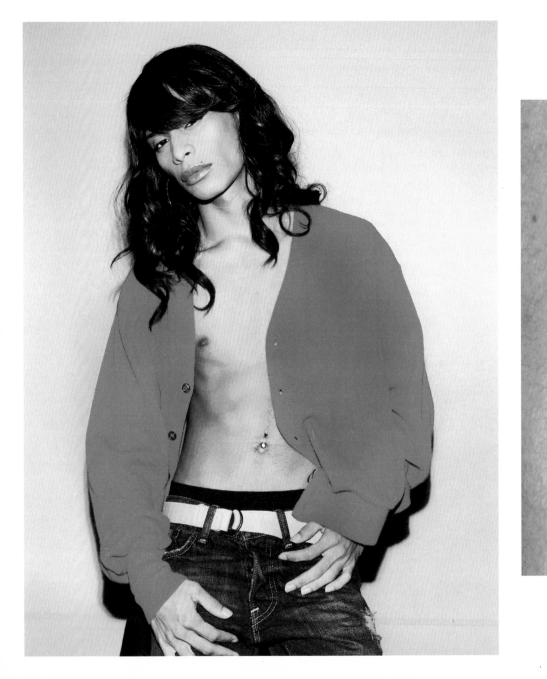

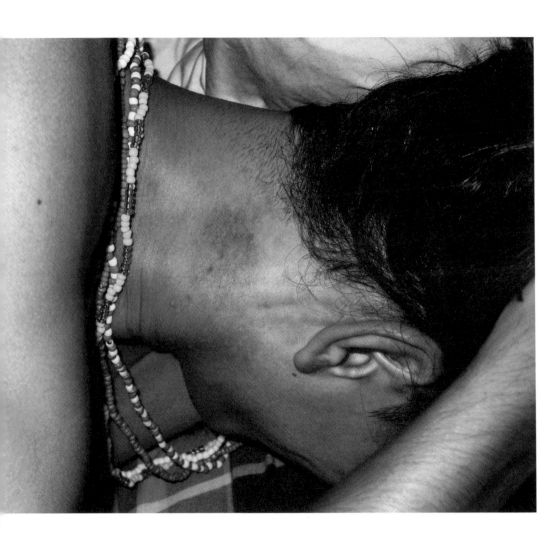

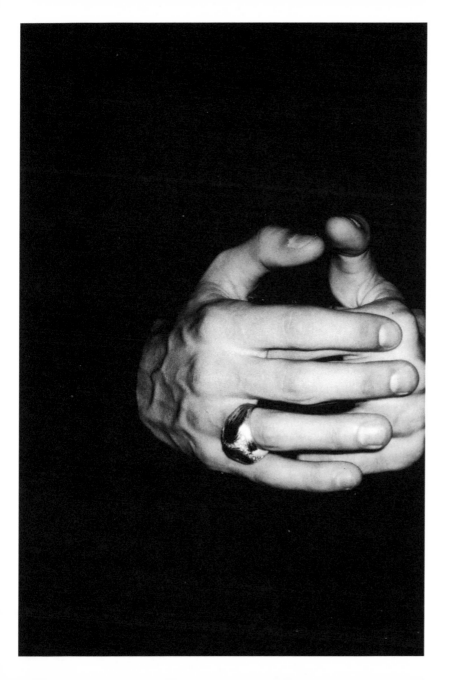

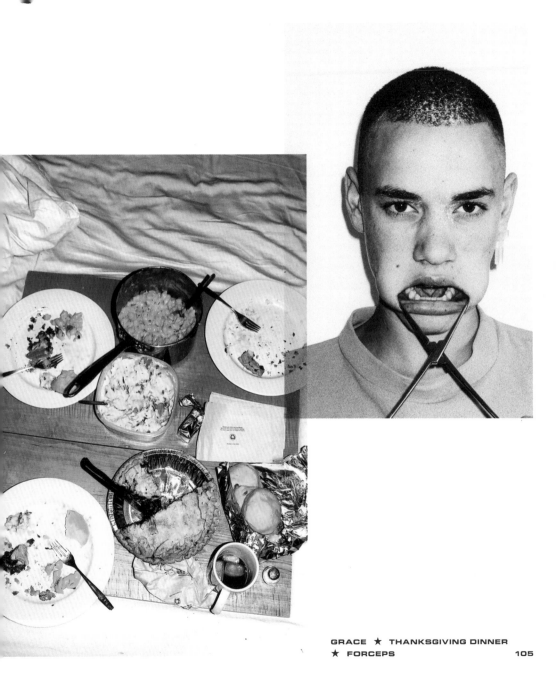

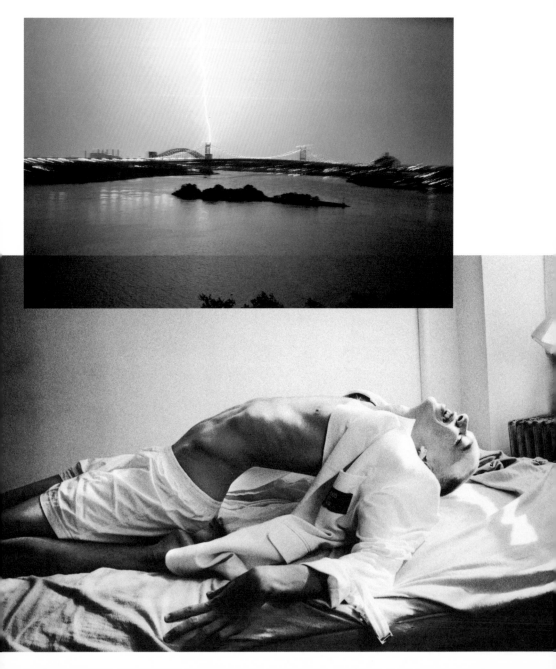

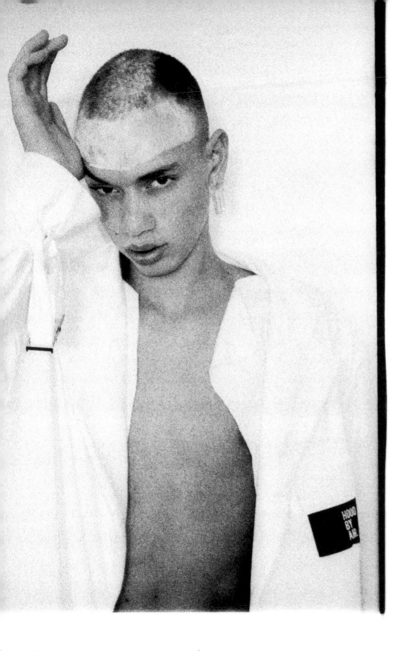

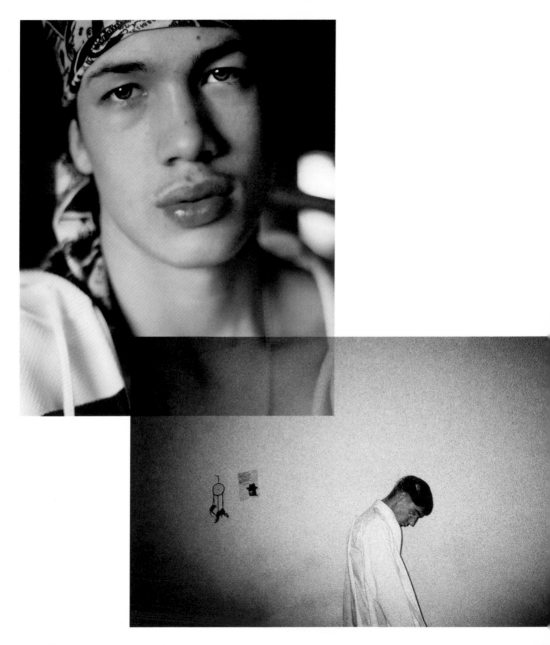

WES ★ DREAMCATCHING ★ CHRISTIAN TREE

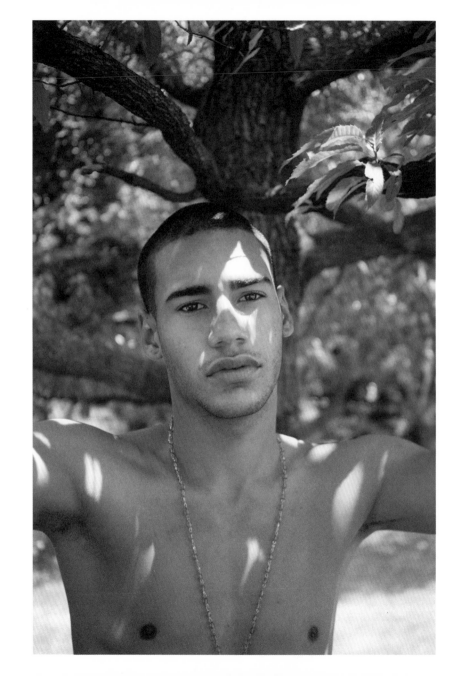

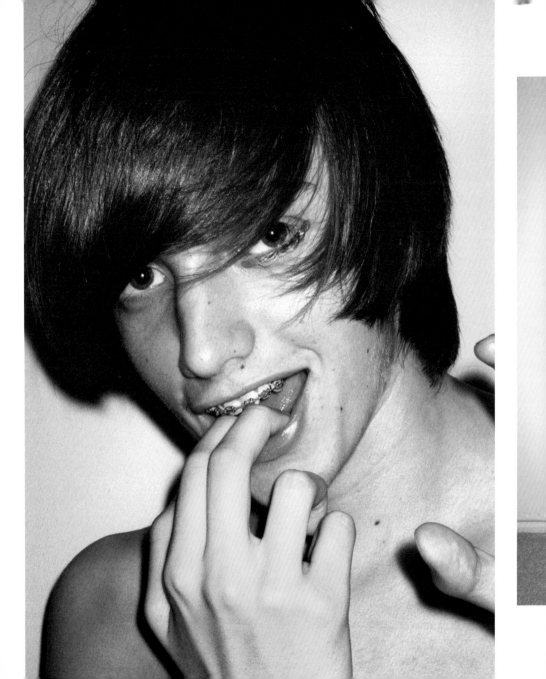

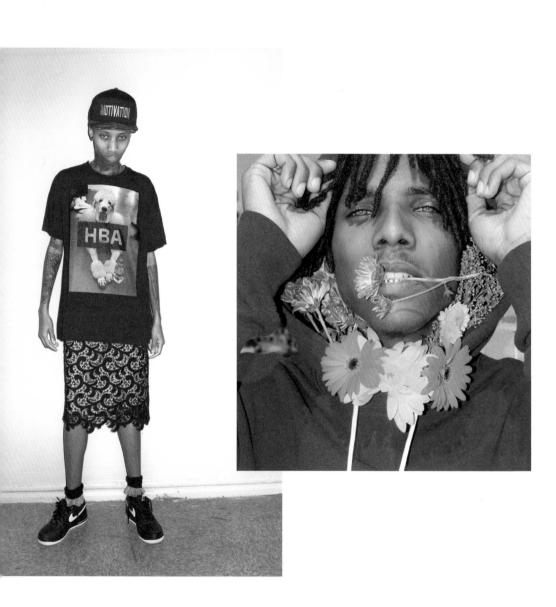

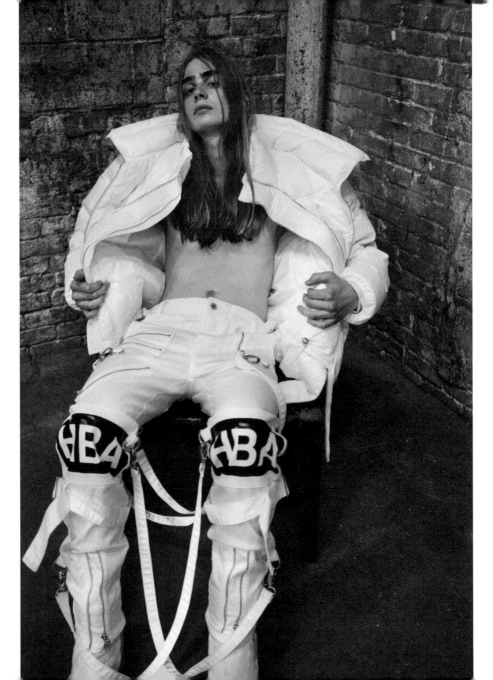

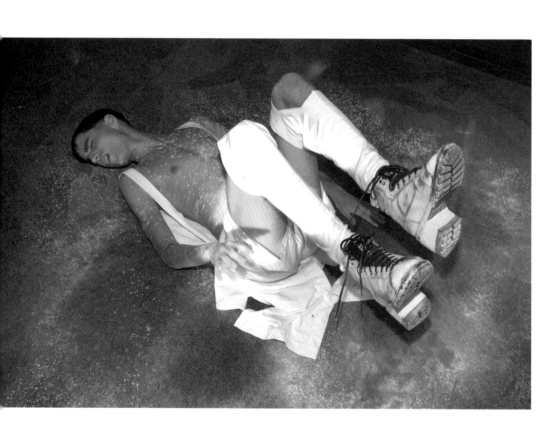

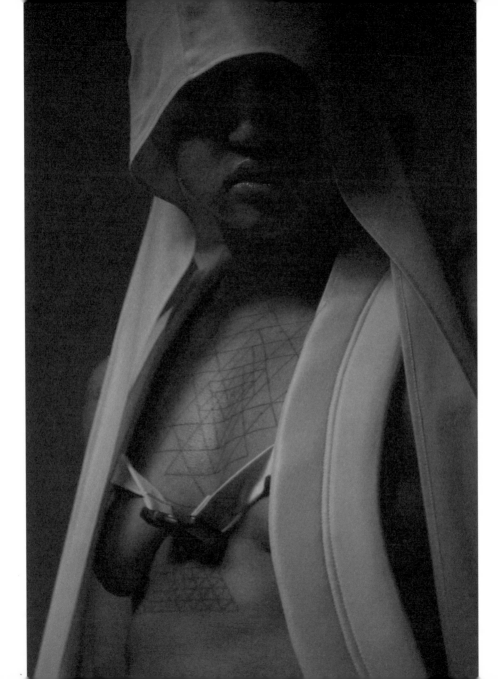

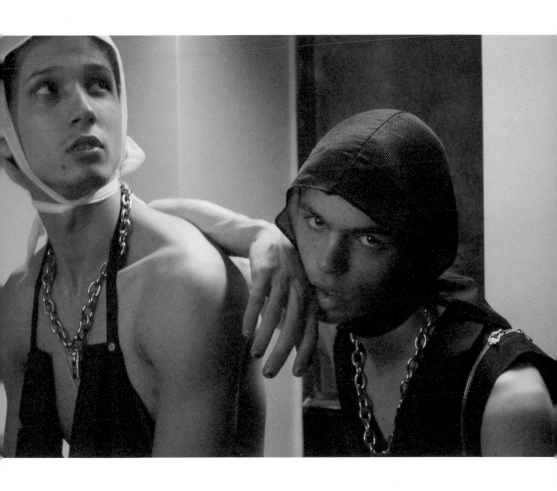

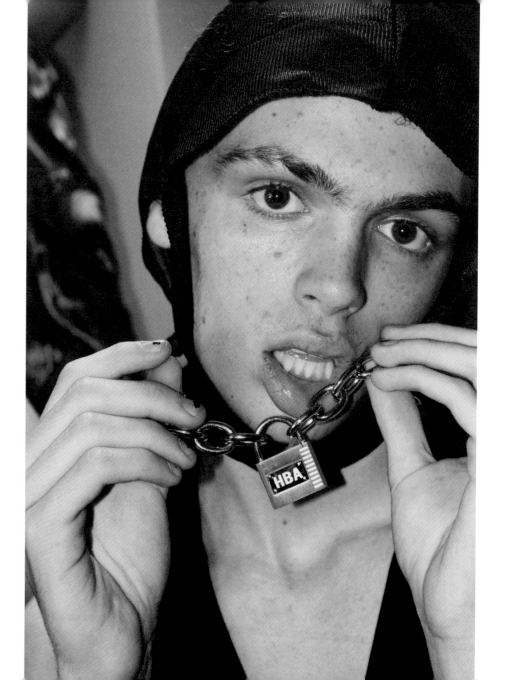

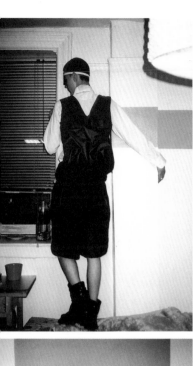

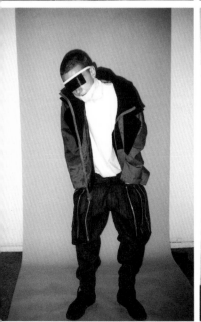
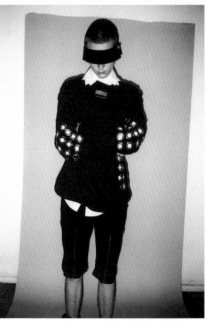

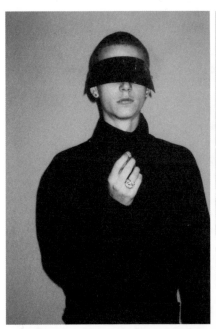
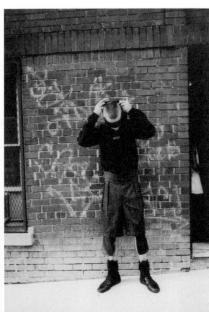
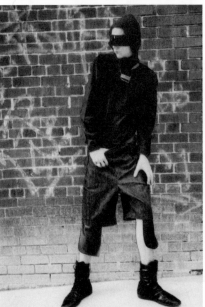
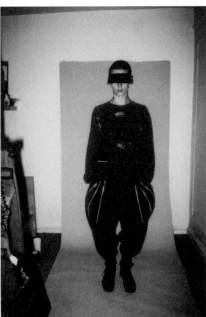

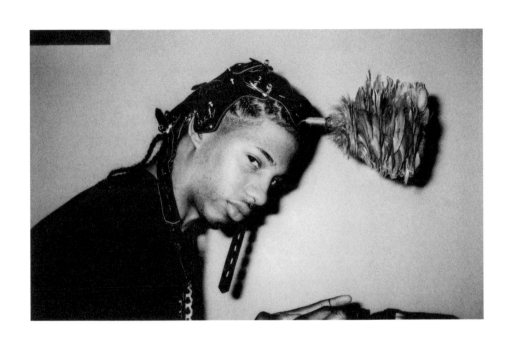

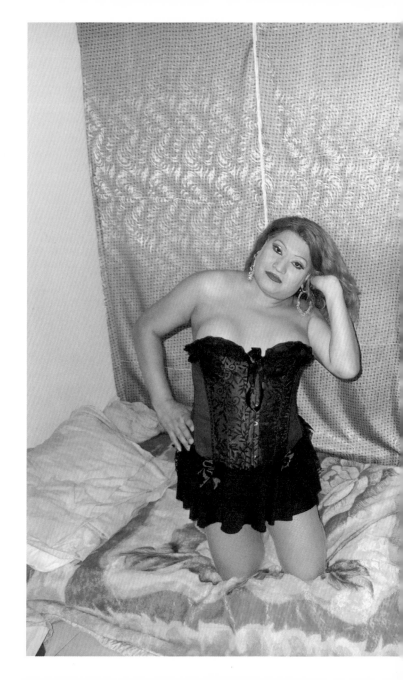

QUEENS, NY

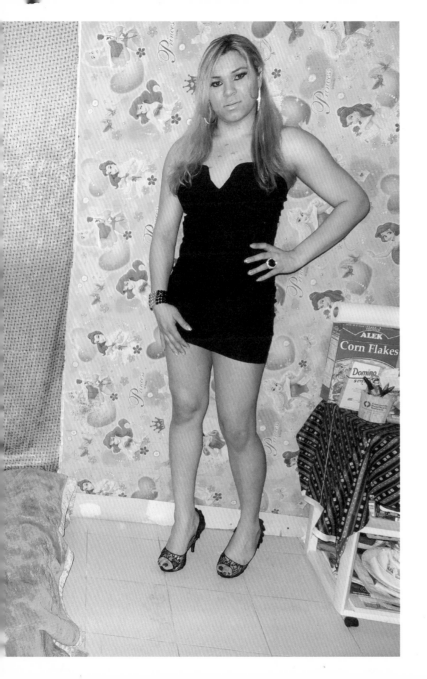

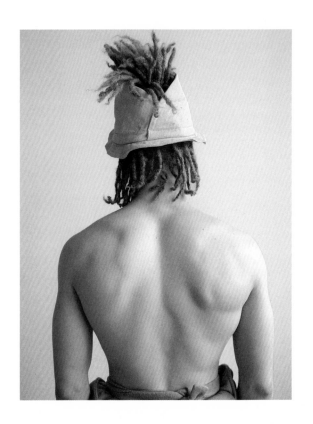

JUSTIN ★ CHIKI MUZZLE

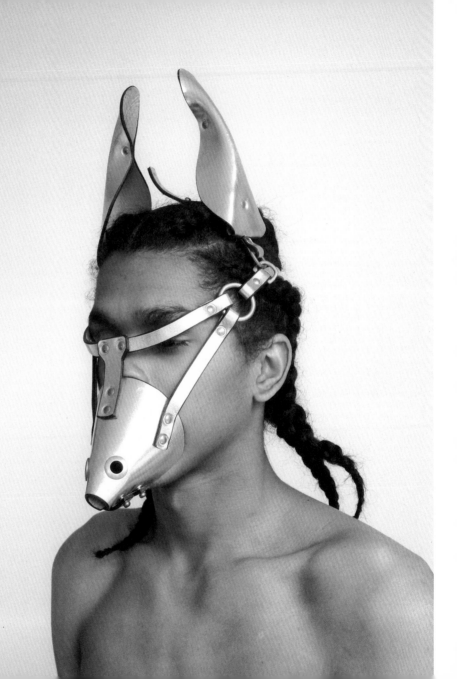

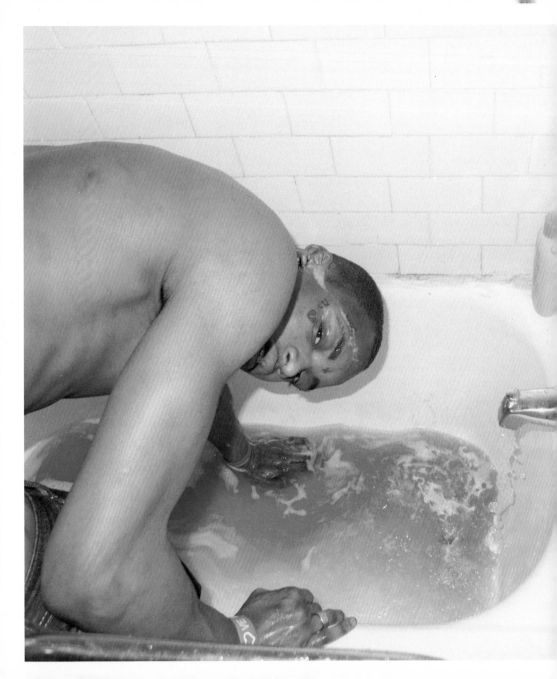

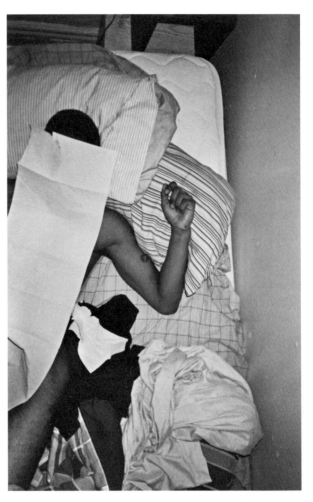

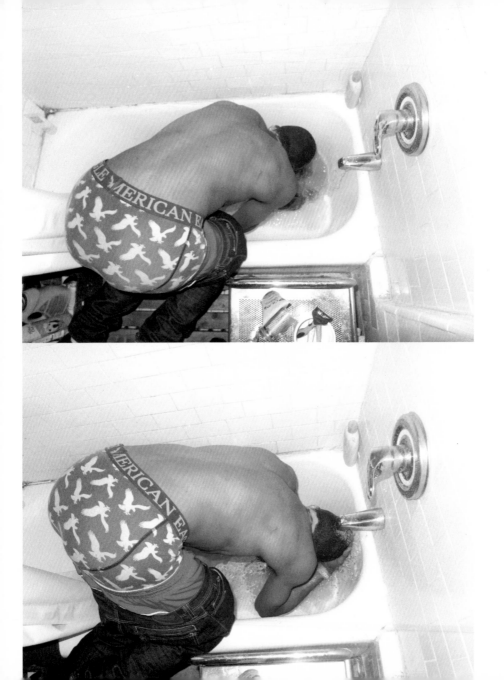

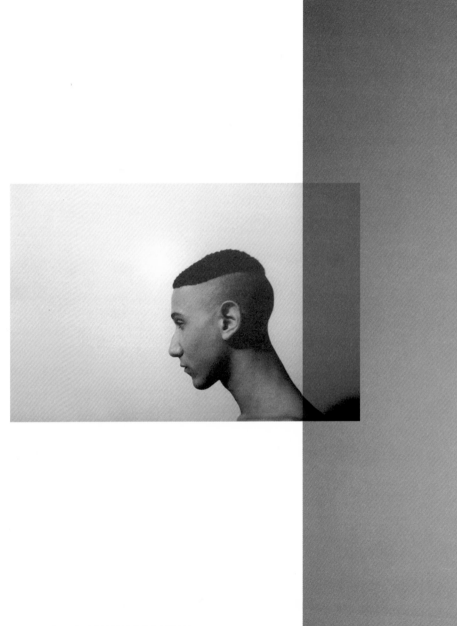

EGYPT ★ BOTTOM HALF OF ABIAH

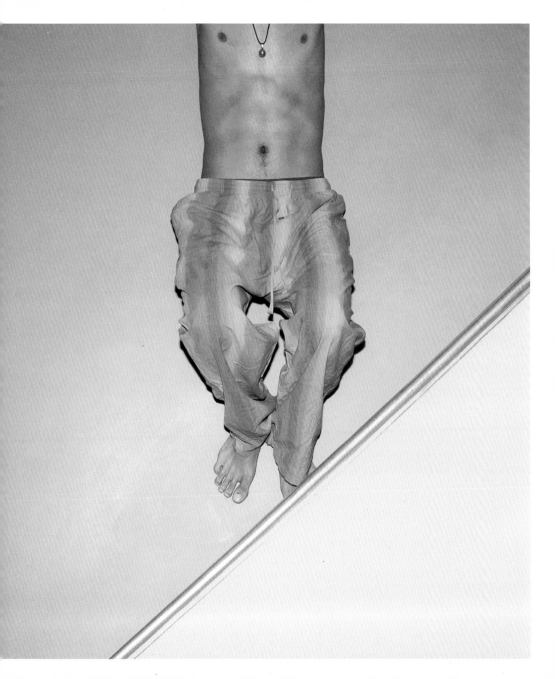

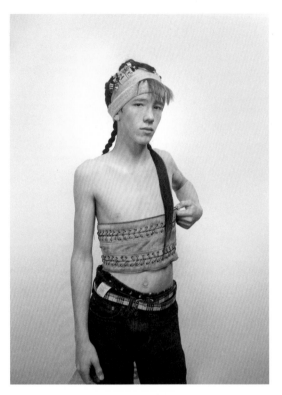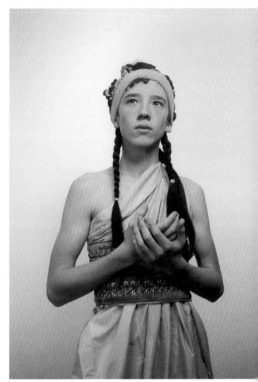

SAINT SERIES / JACKSON

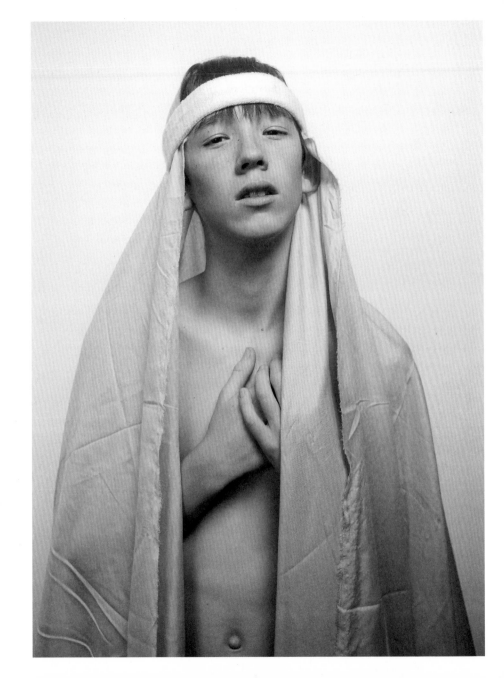

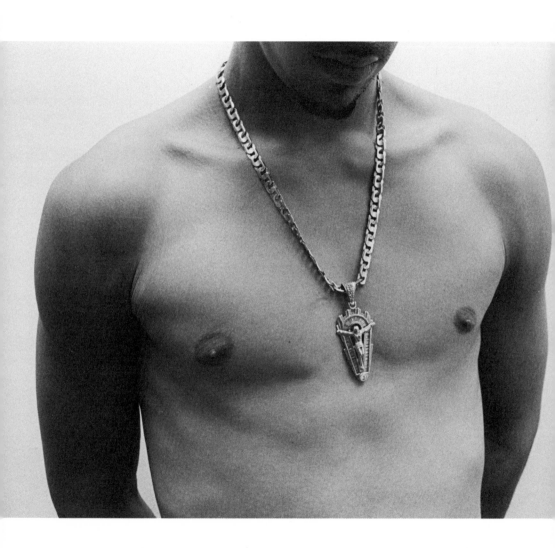

CHEST ★ THANKSGIVING ORGANS

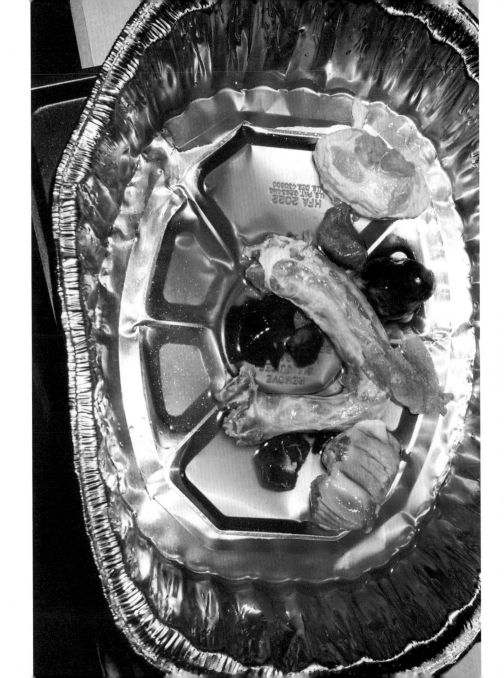

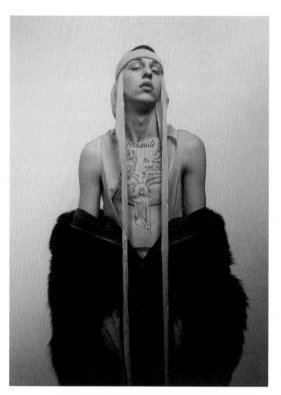
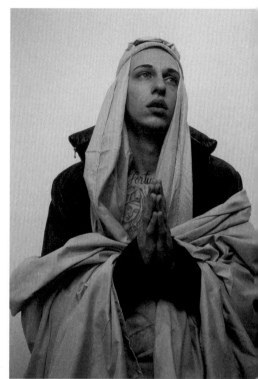

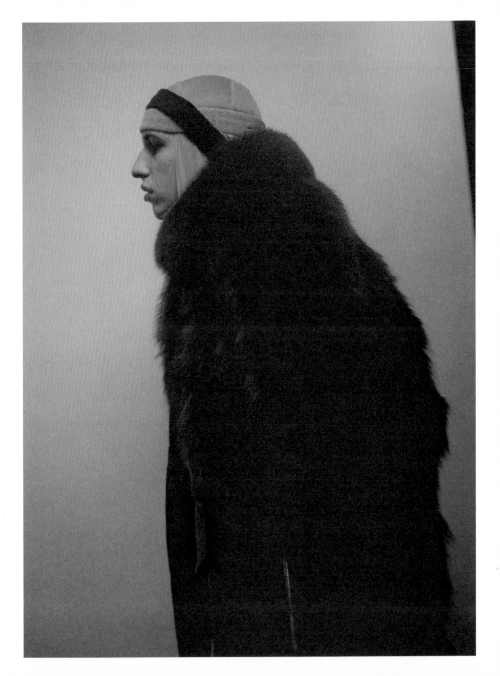

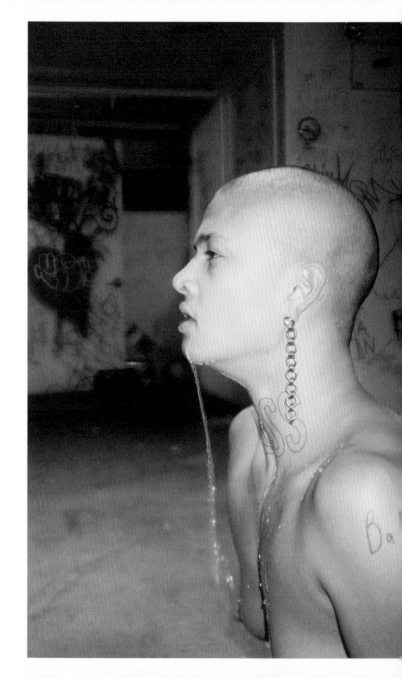

TOSH ★ CHUCK HEARTS

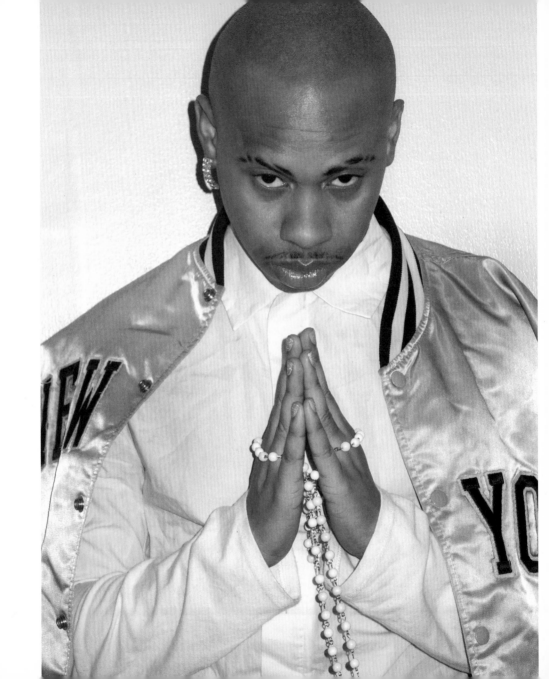

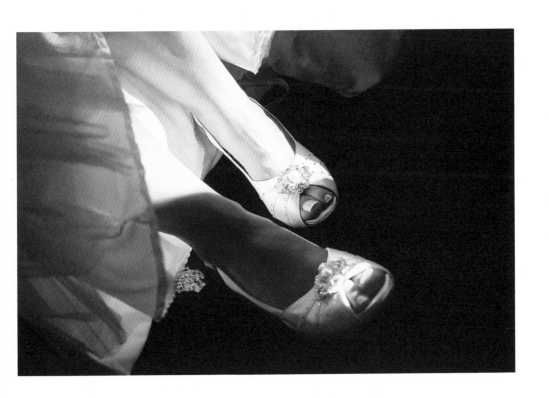

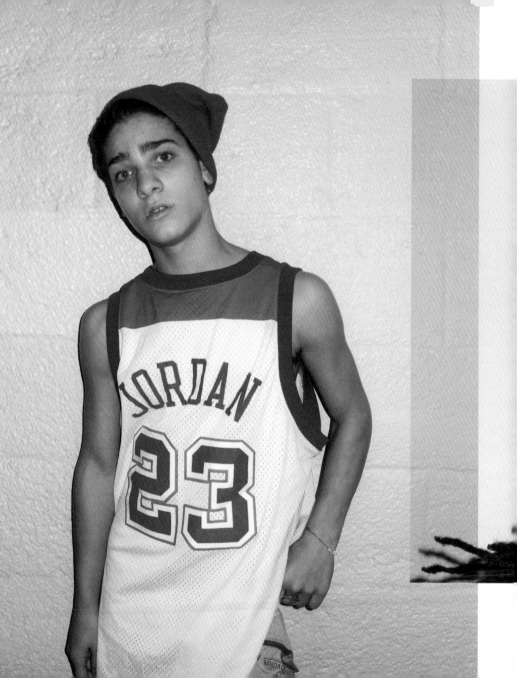

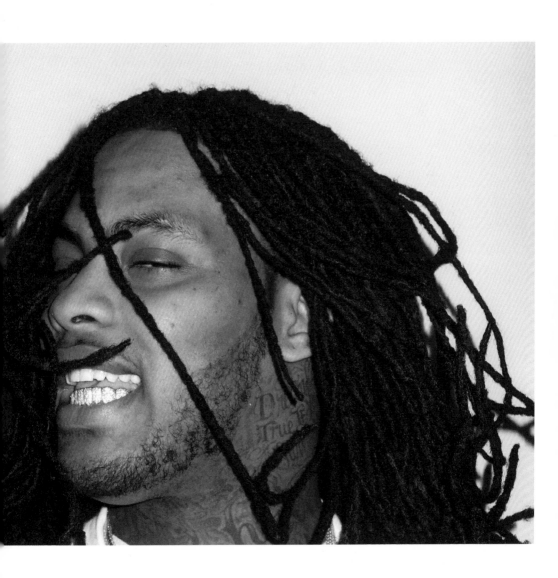

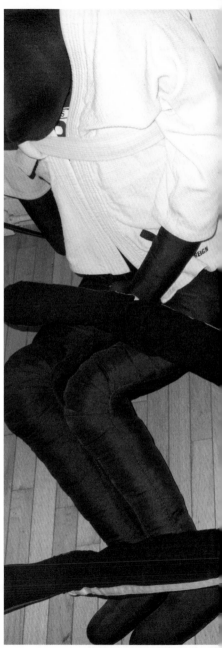

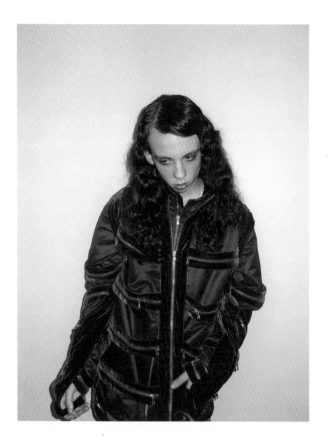

BABY MANSON ★ LUKA PUNCH DUMMY

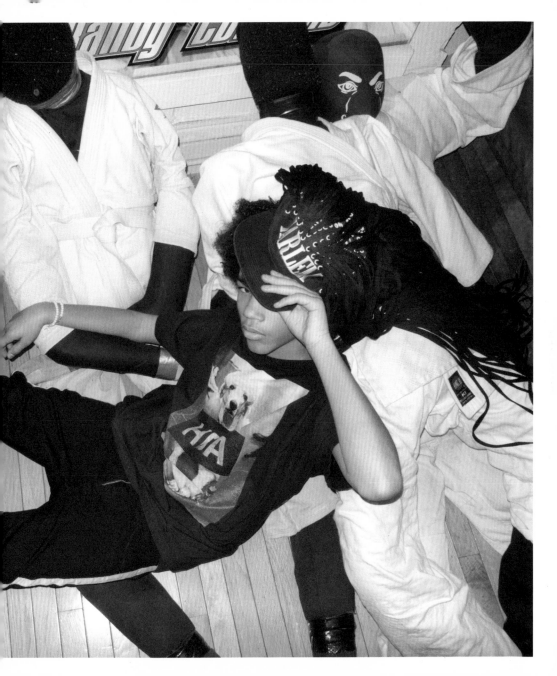

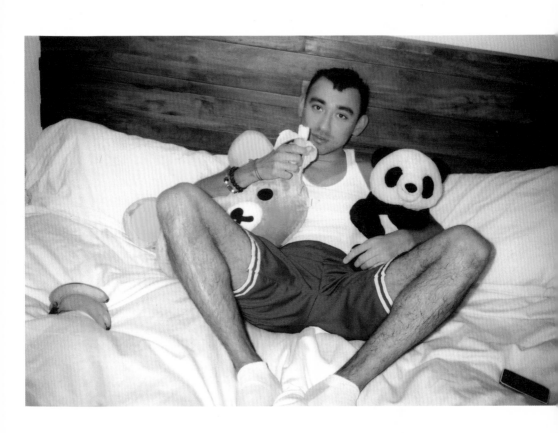

NICOLA ★ PUPPY BOY, NOLA

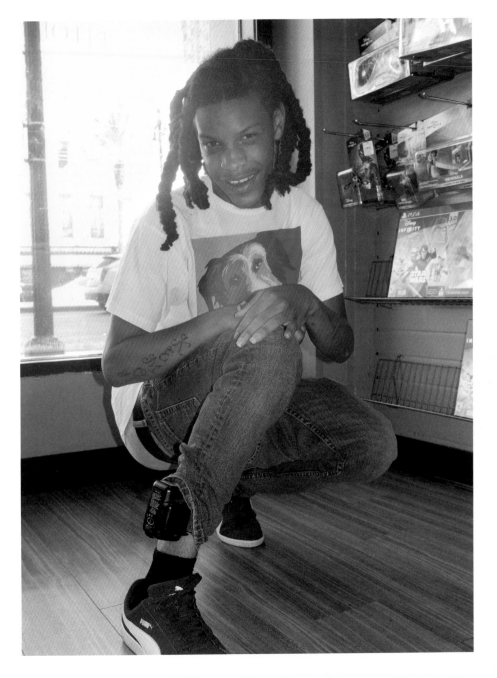

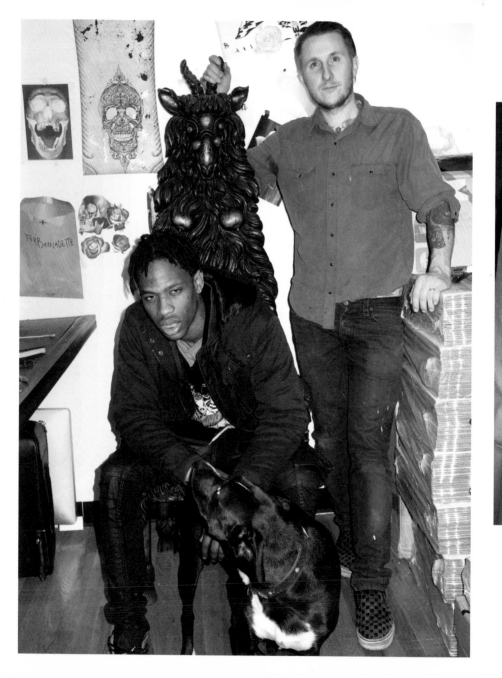

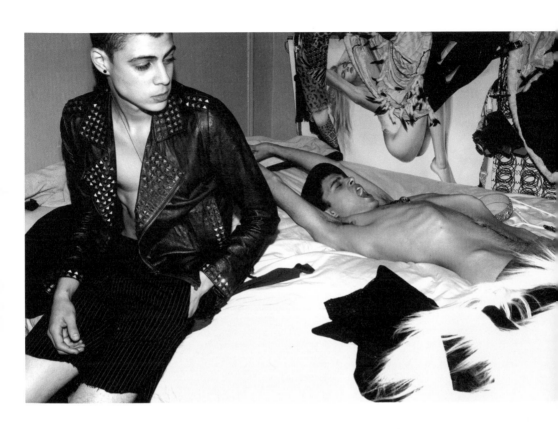

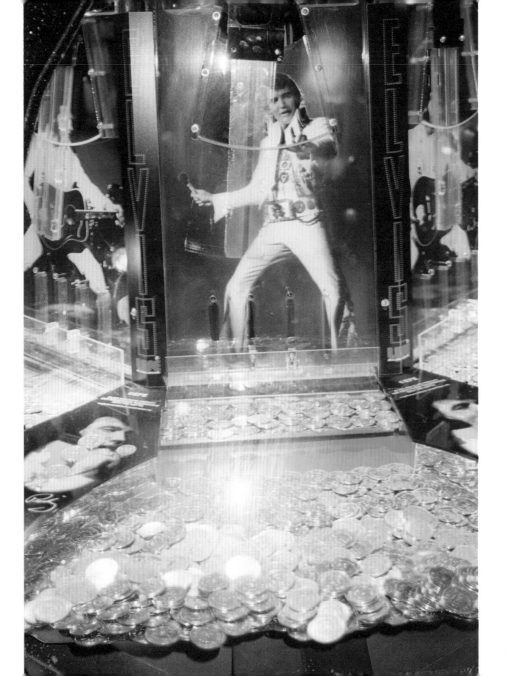

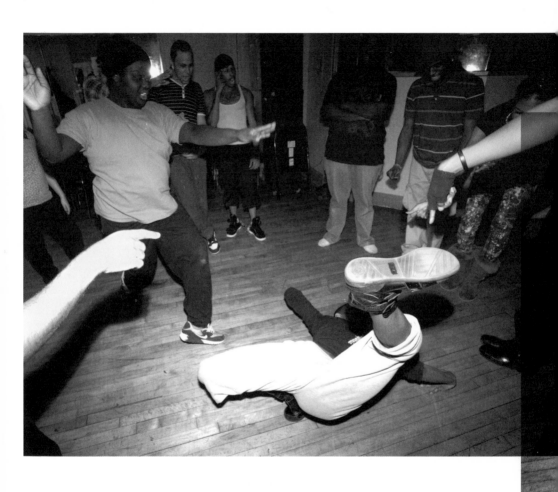

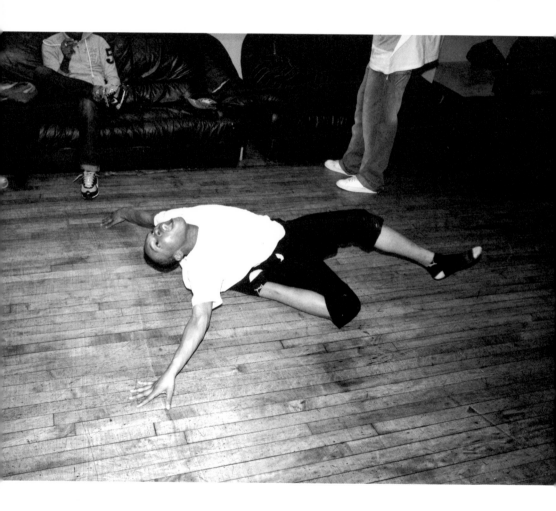

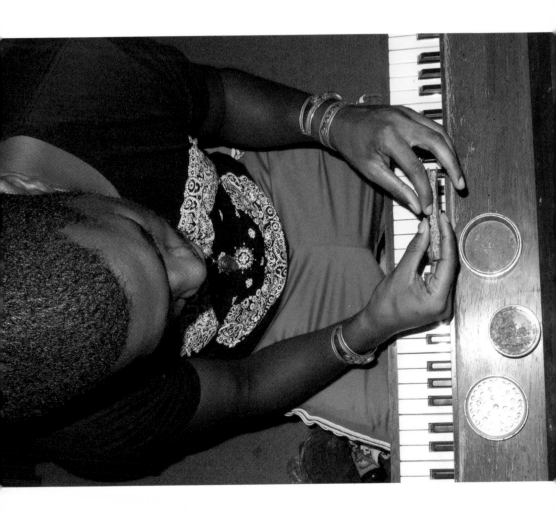

FLYLO ROLL UP ★ BEACH PIT

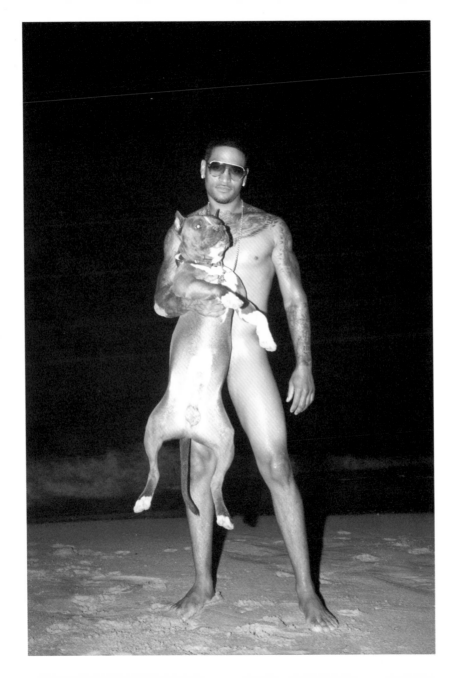

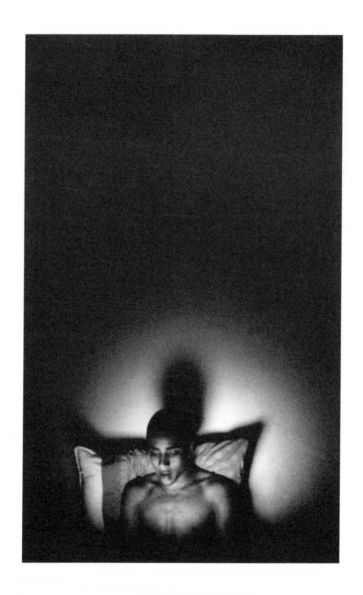

BLUE GLOW BOY ★ ABIAH

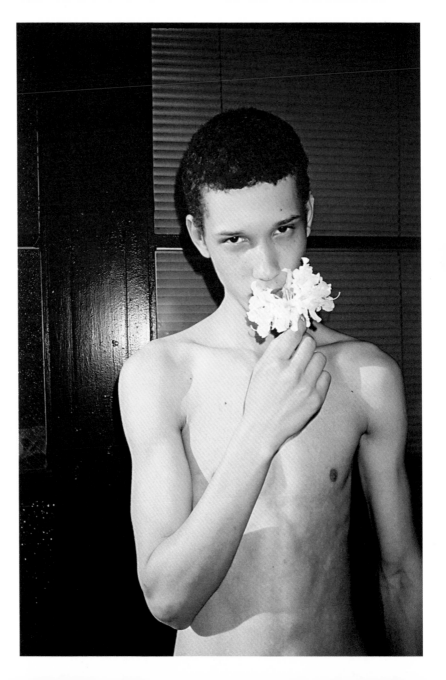

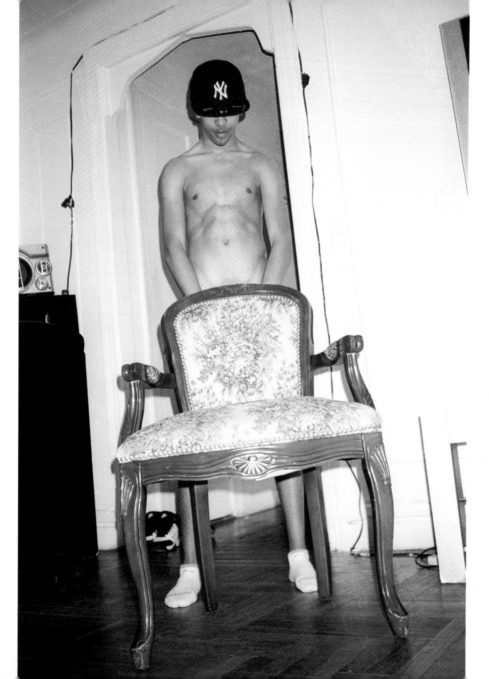

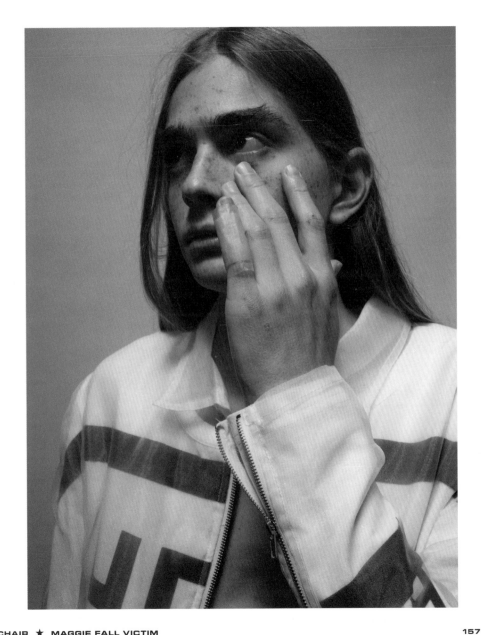

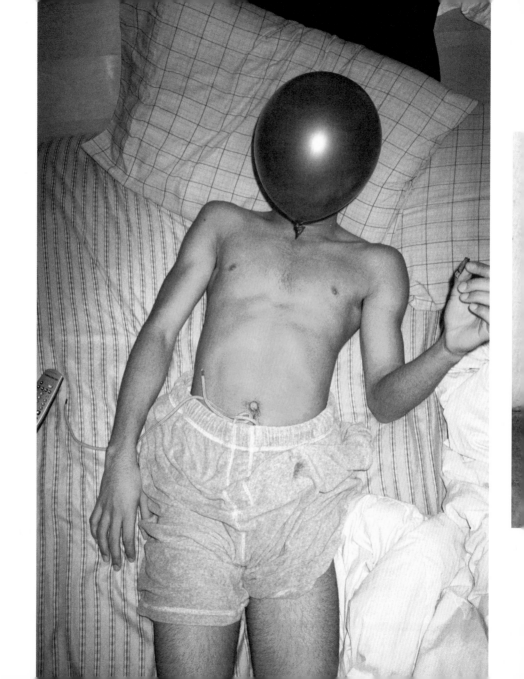

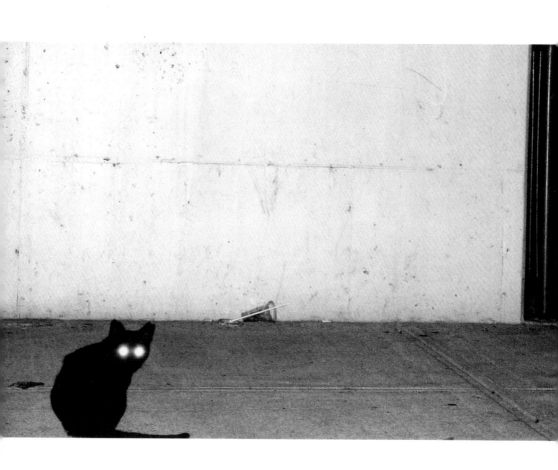

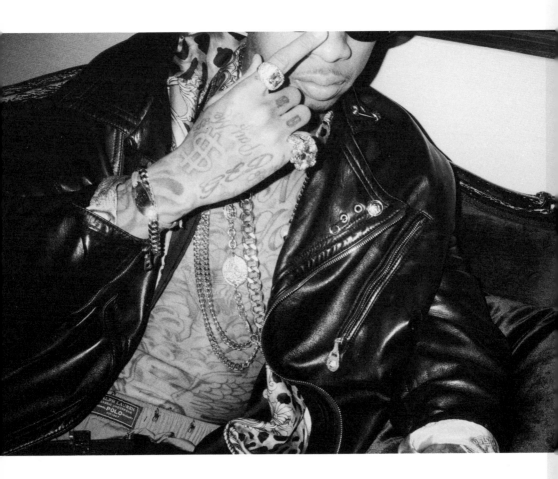

TYGA

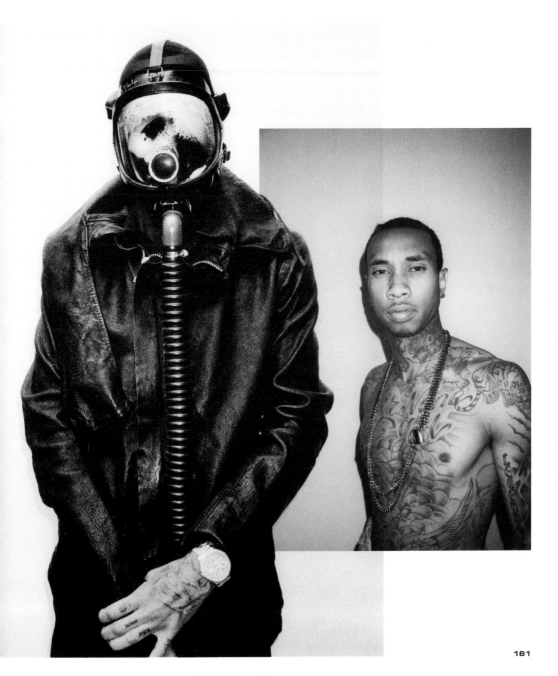

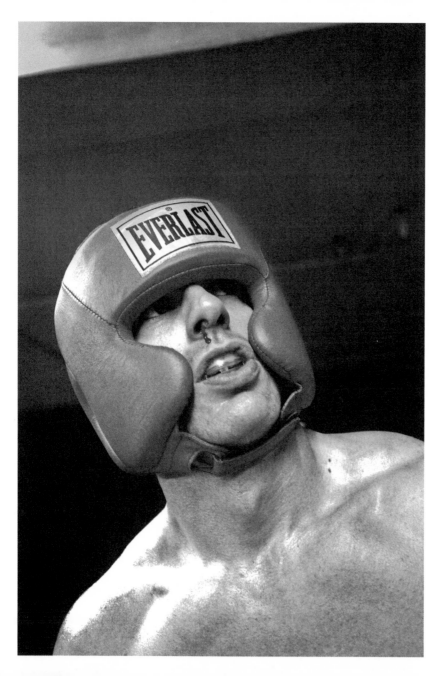

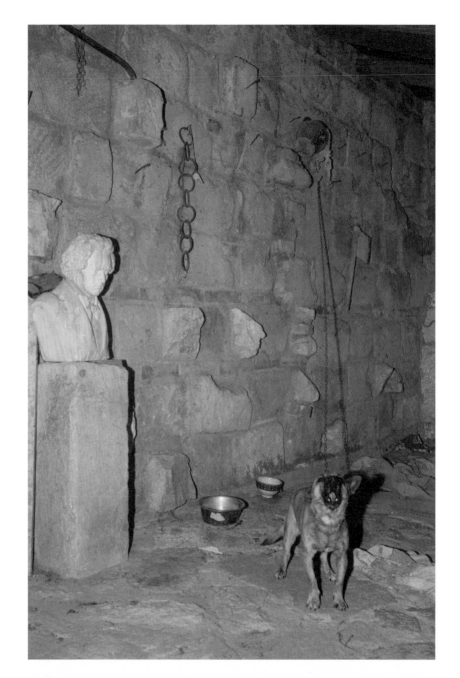

CINDERELLA MAN

BEETHOVEN
BOMB SHELTER

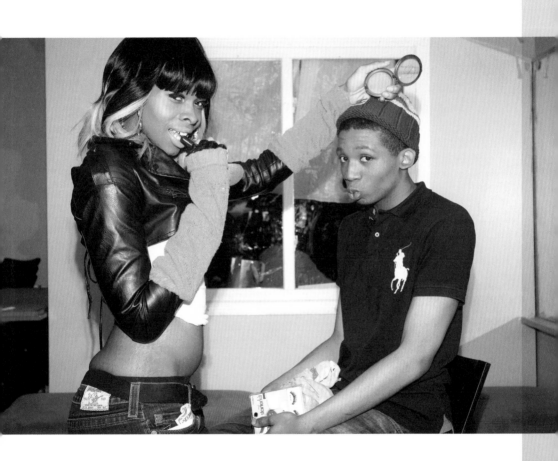

DAWTAH ★ MYKKI PONY BOY ★ LEE

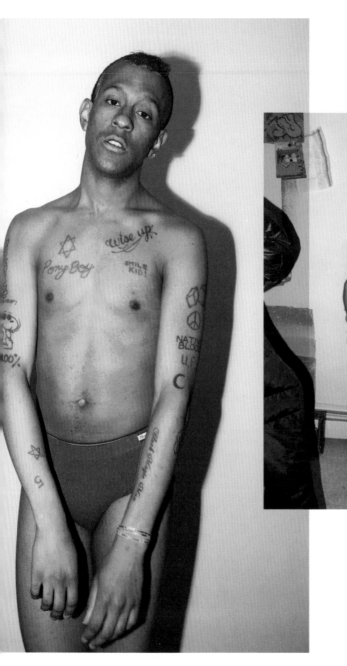
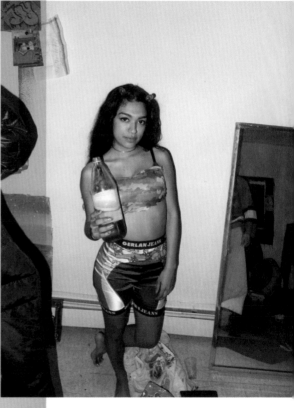

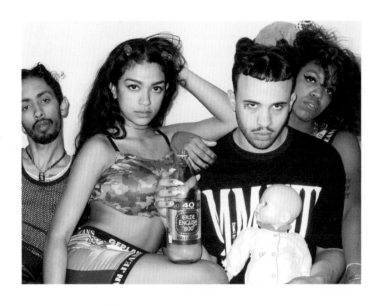

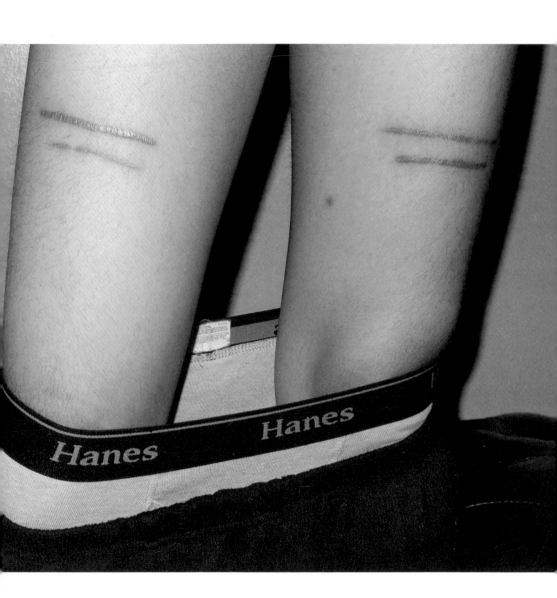

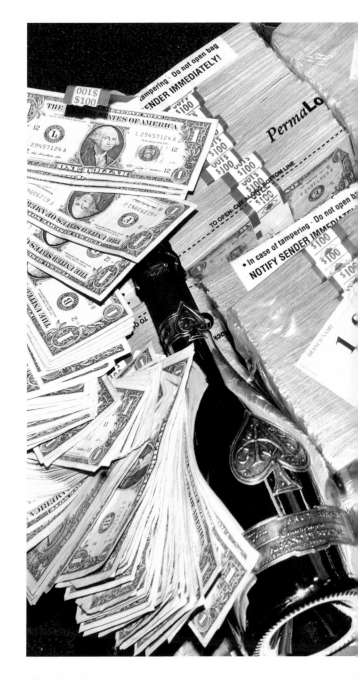

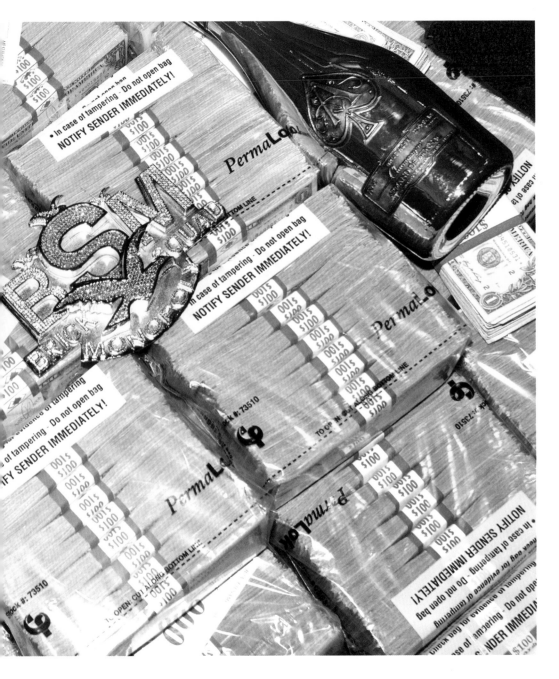

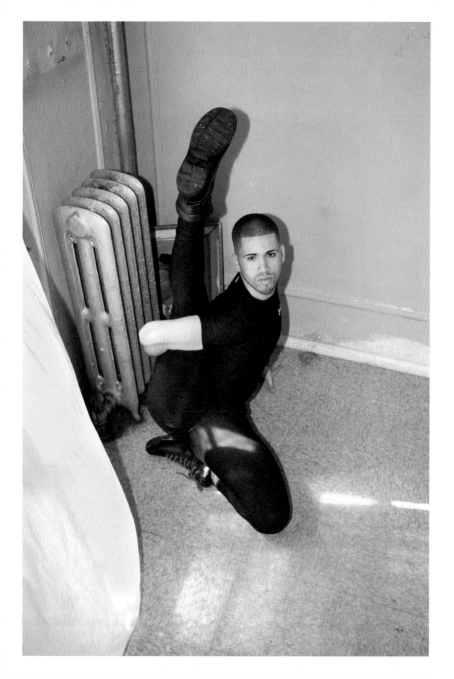

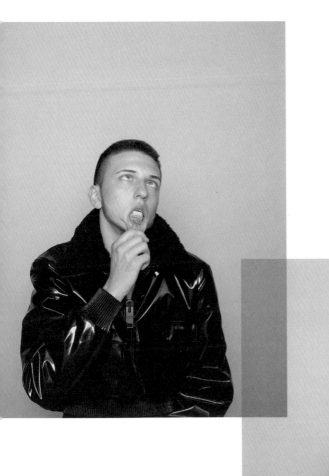

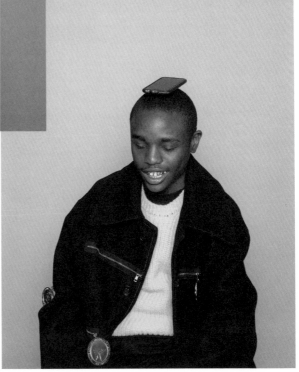

ERK ★ JOSEPH ★ ADE

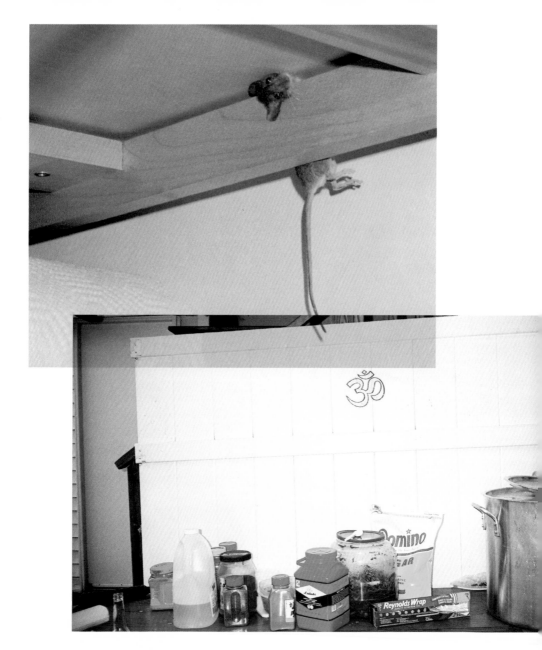

MOUSETRAP ★ OZONE PARK ★ MAGGIE

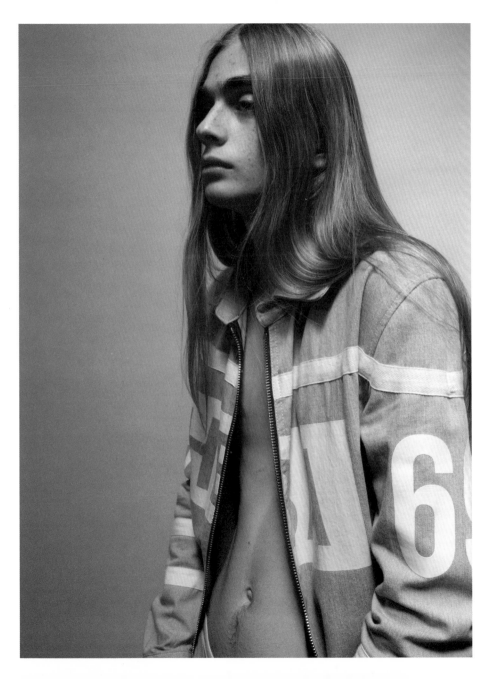

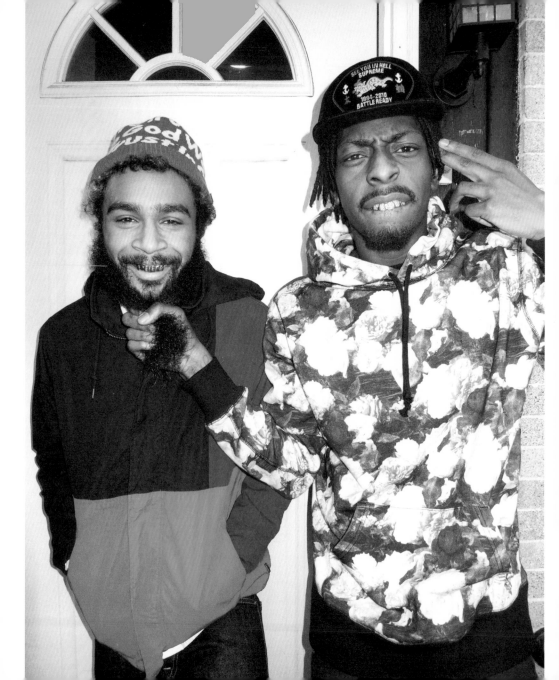

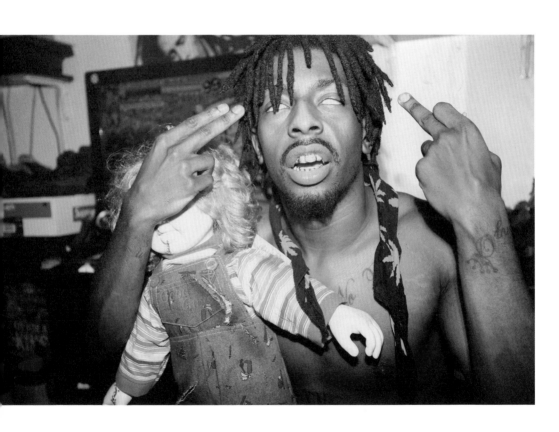

PLASTIC BEARS ★ A$AP FERG

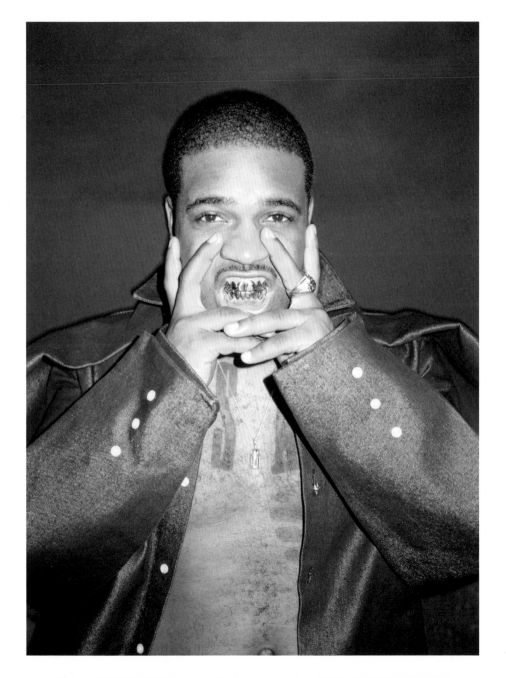

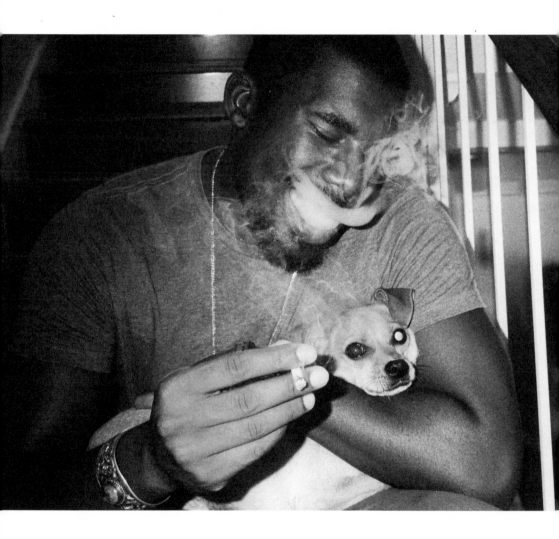

FLYLO + PUP AT HOME

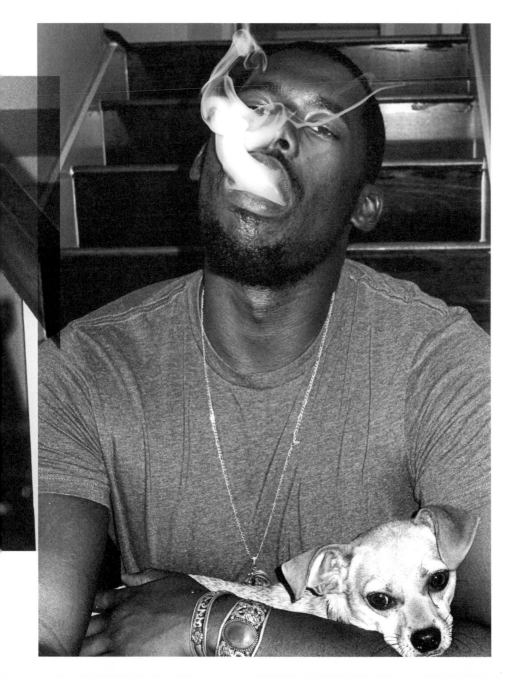

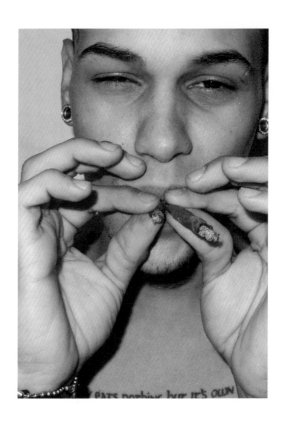

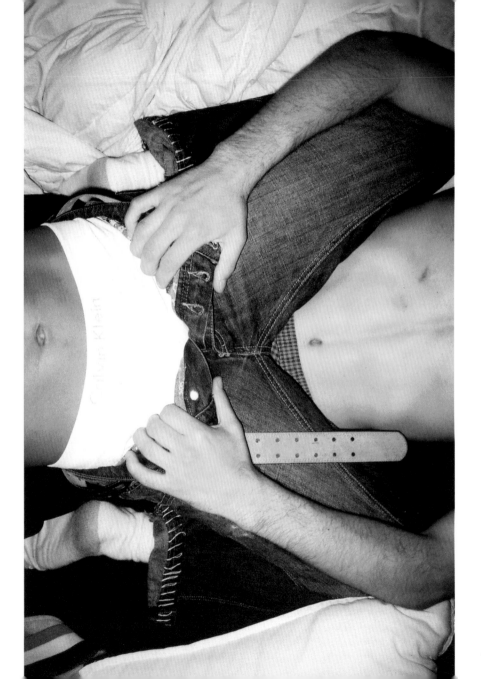

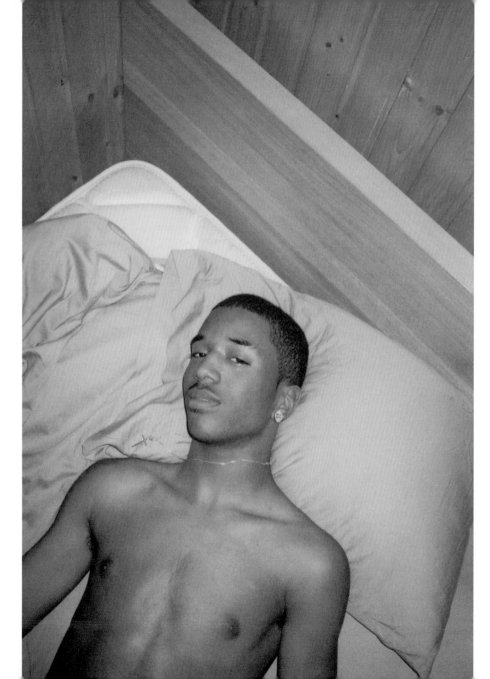

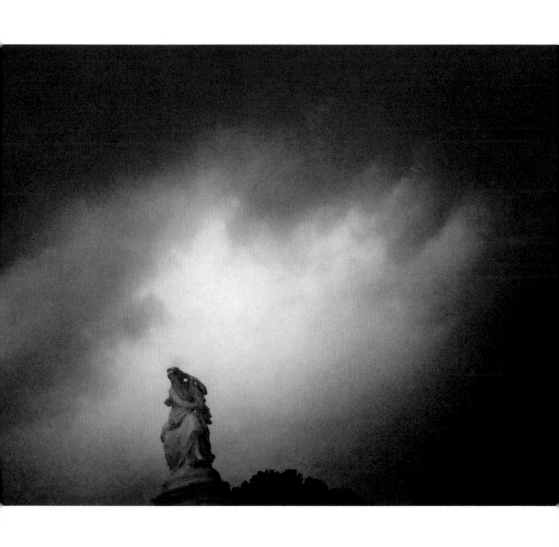

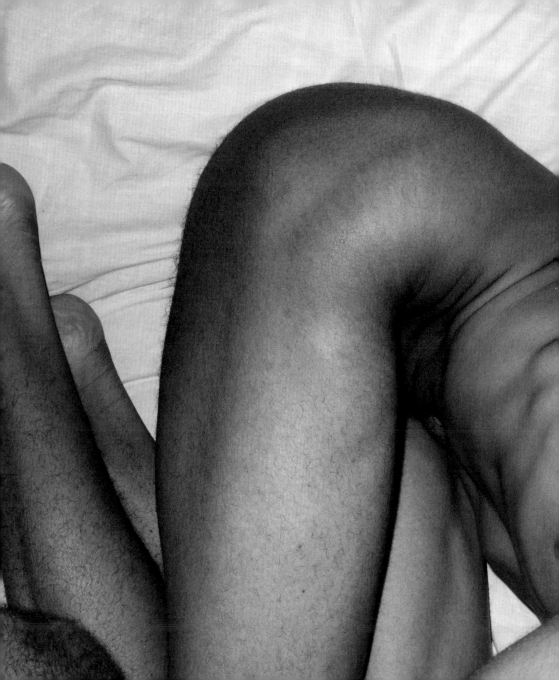

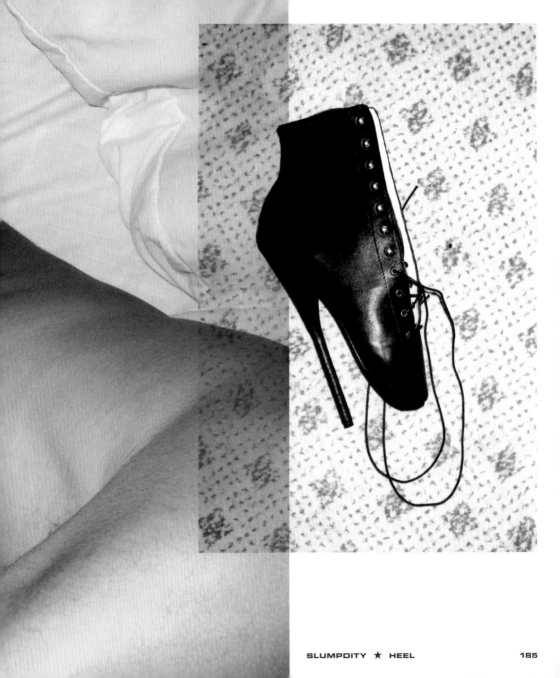

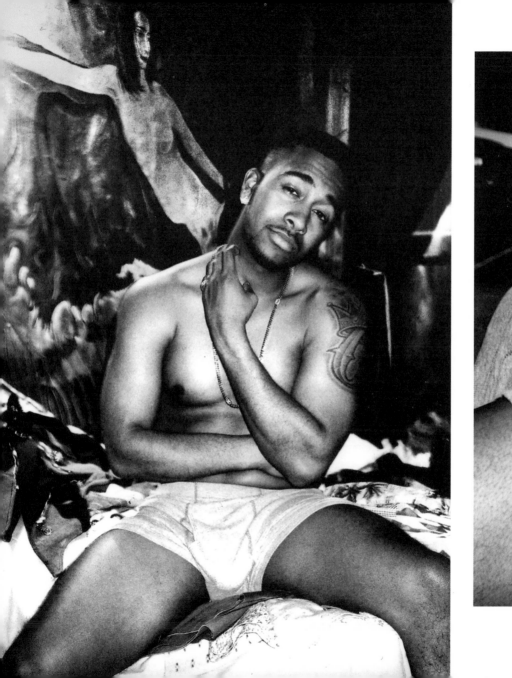

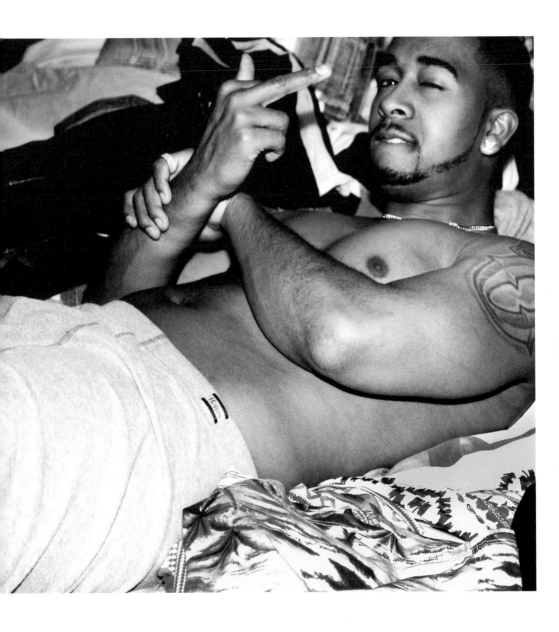

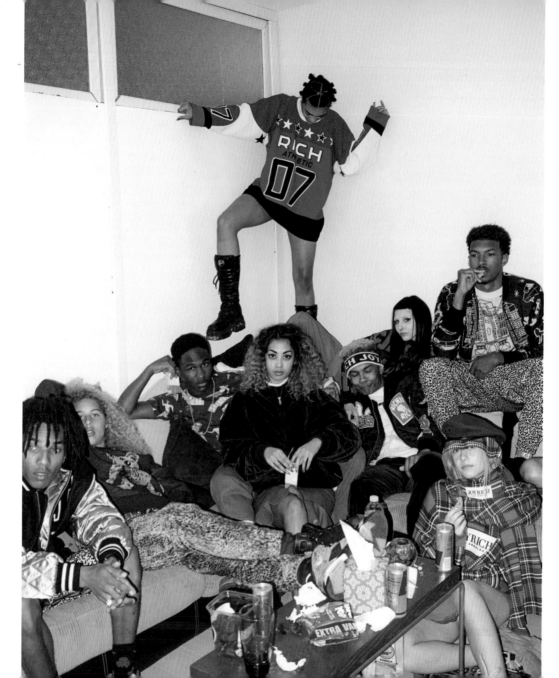

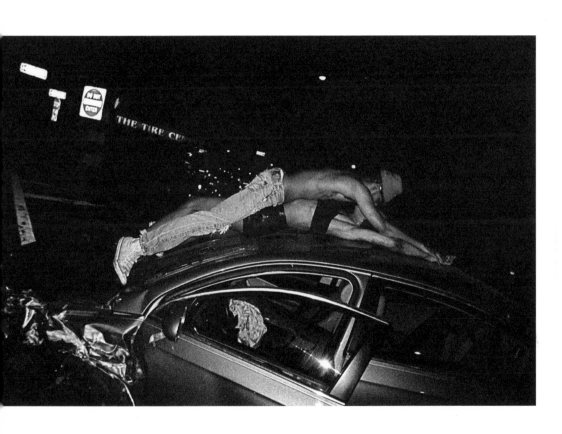

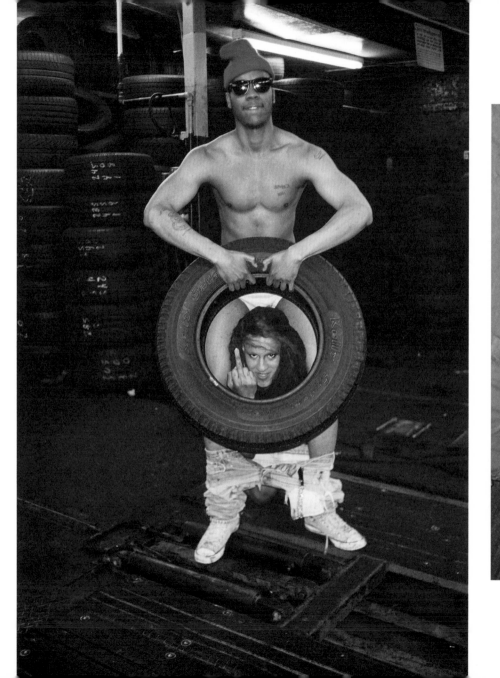

PIT BULL ★ TRAVIS GRILL

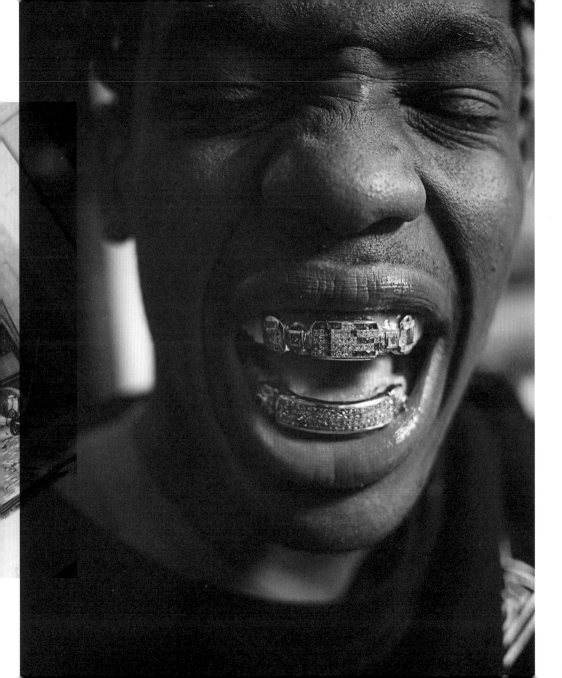

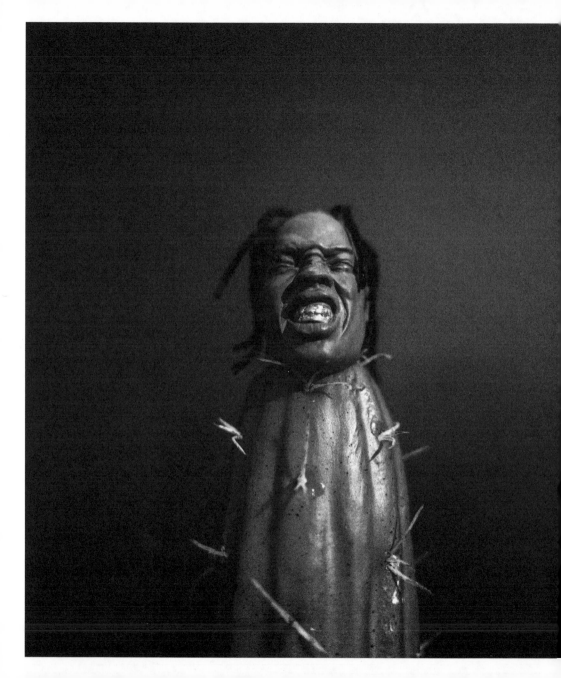

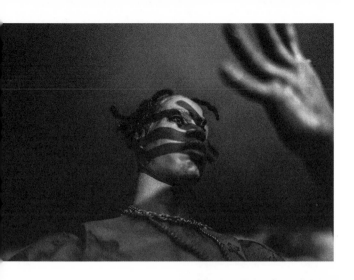

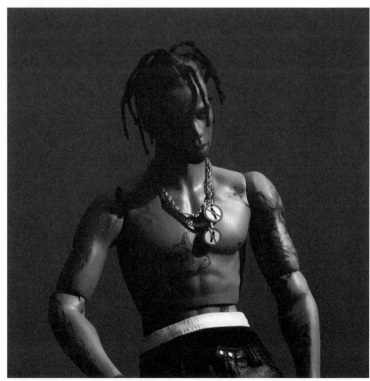

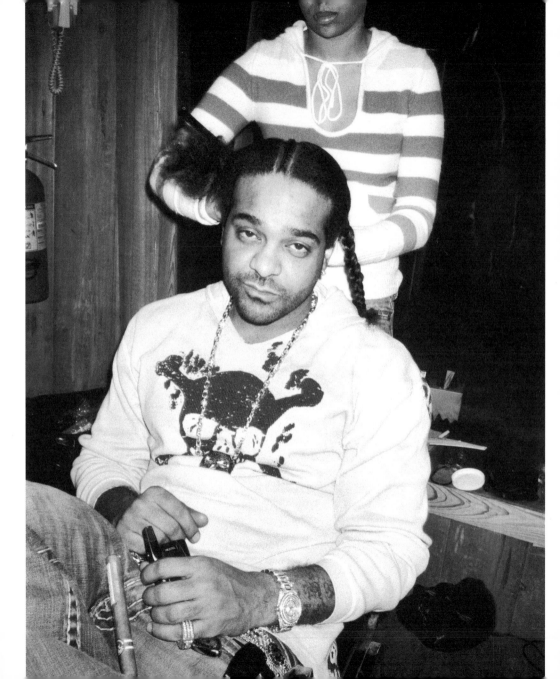

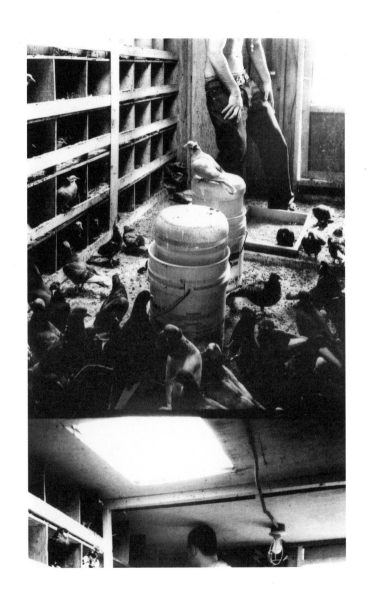

COOP 2

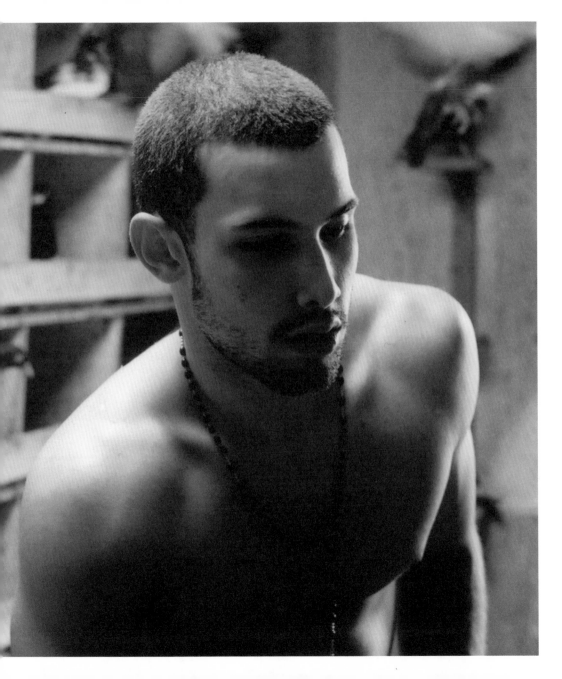

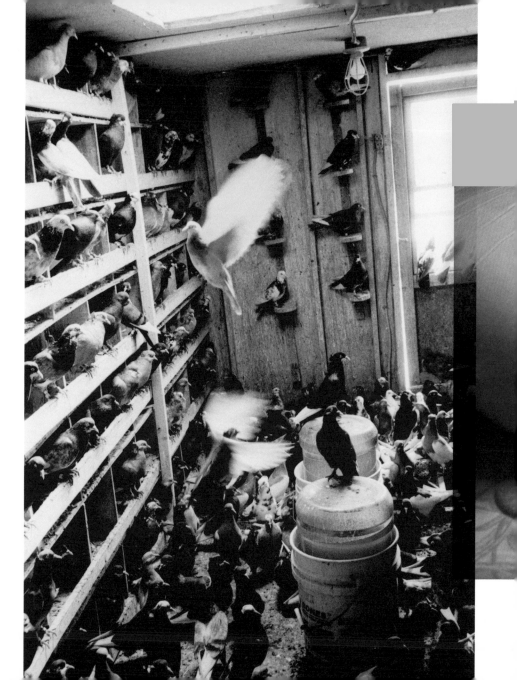

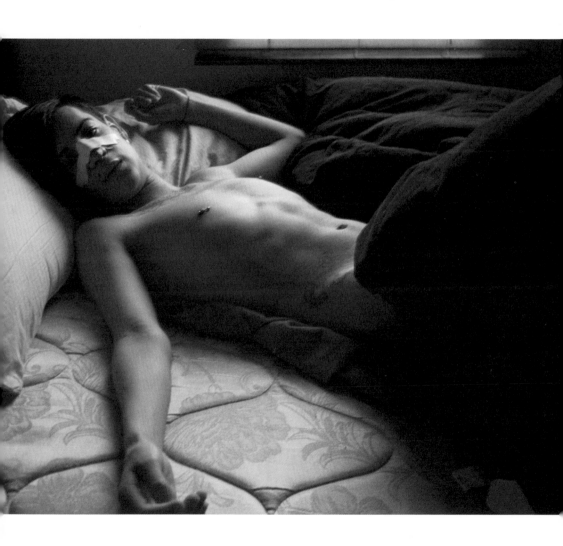

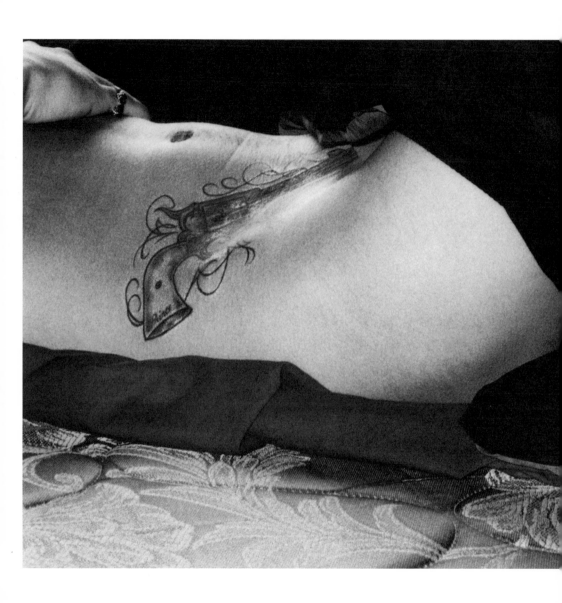

PRINCE TATT ★ FOX

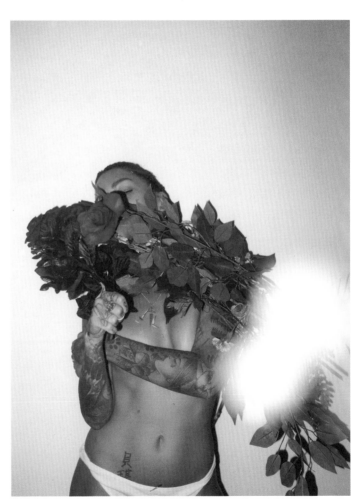

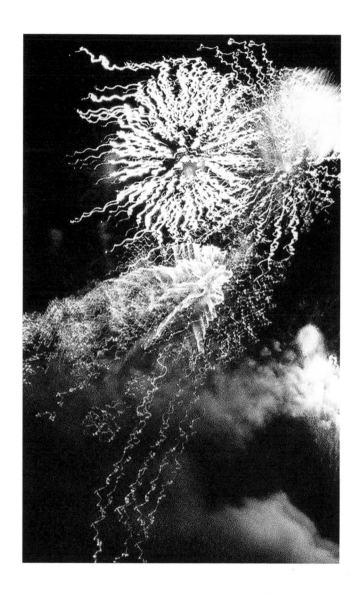

FIREWORKS ★ VASHTIE

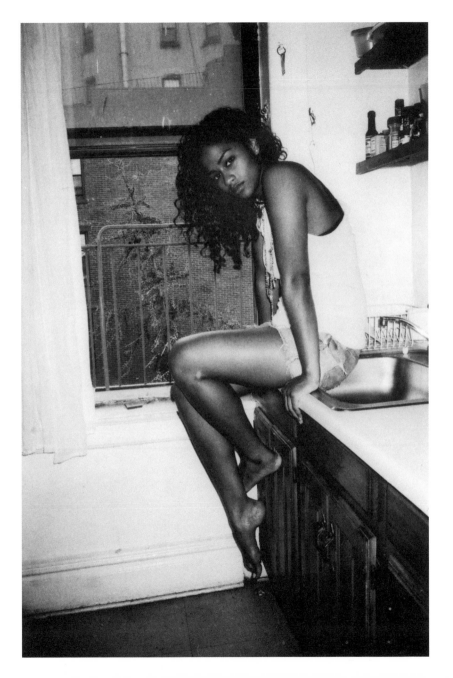

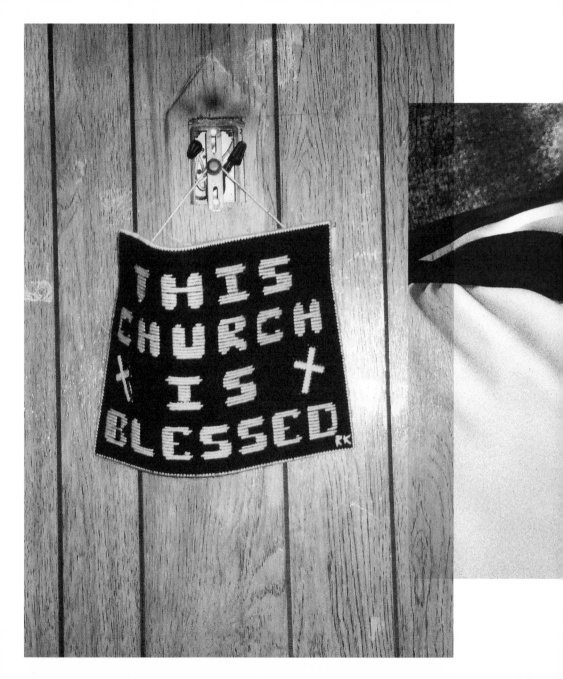

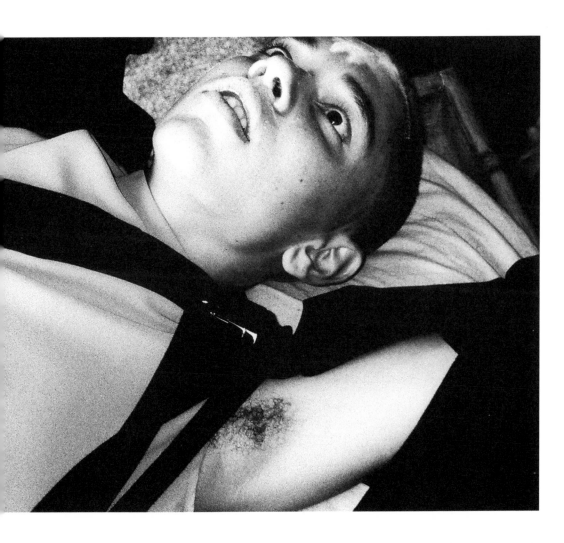

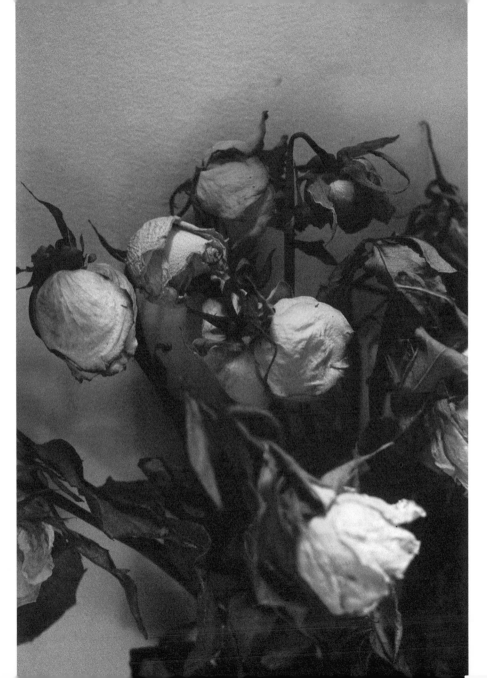

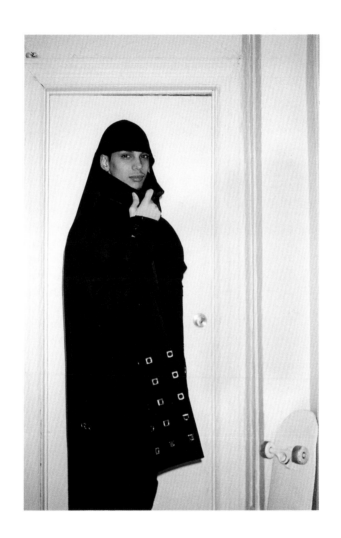

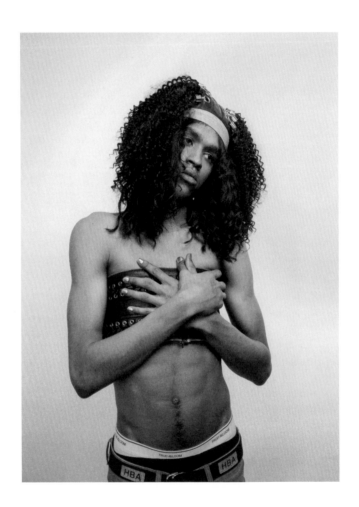

SAINT CHIKI ★ FIRST TEETH

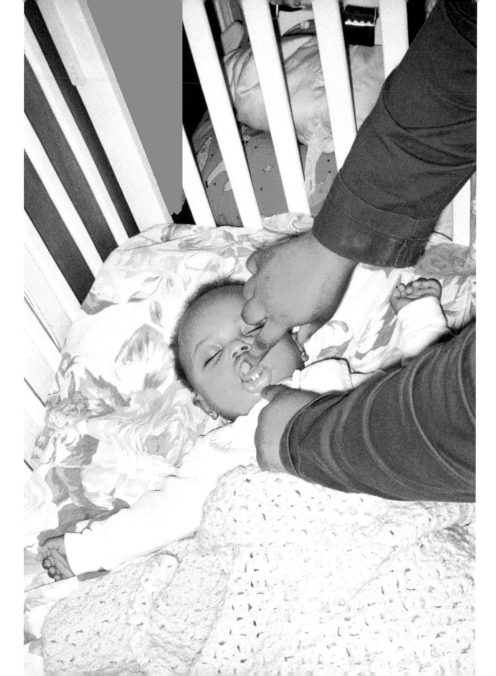

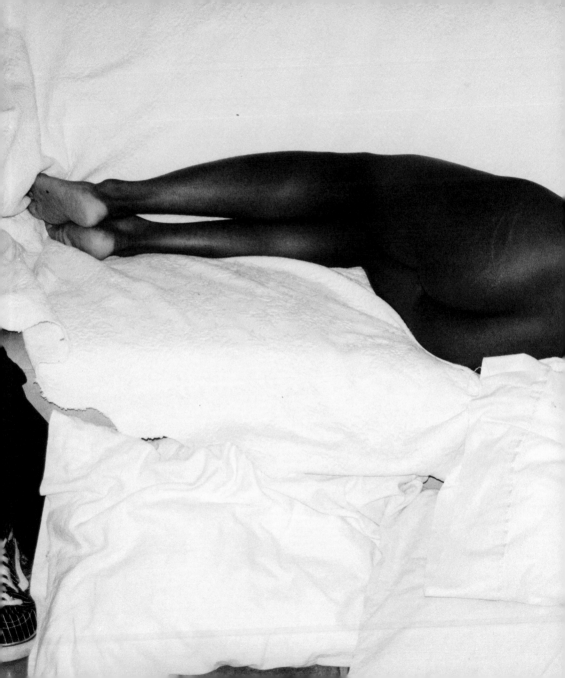

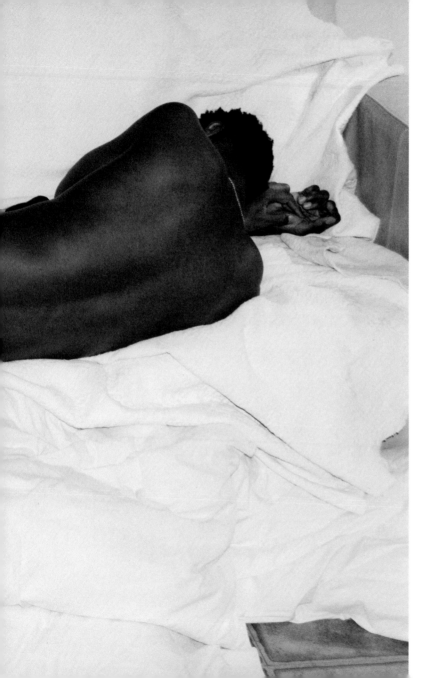

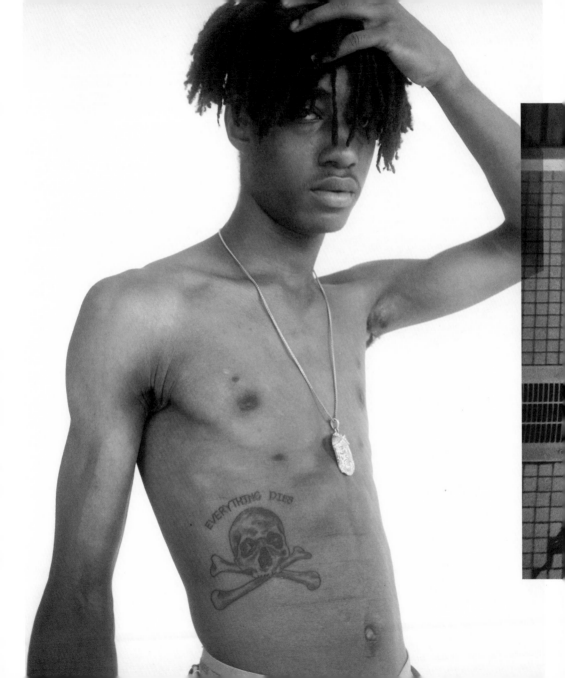

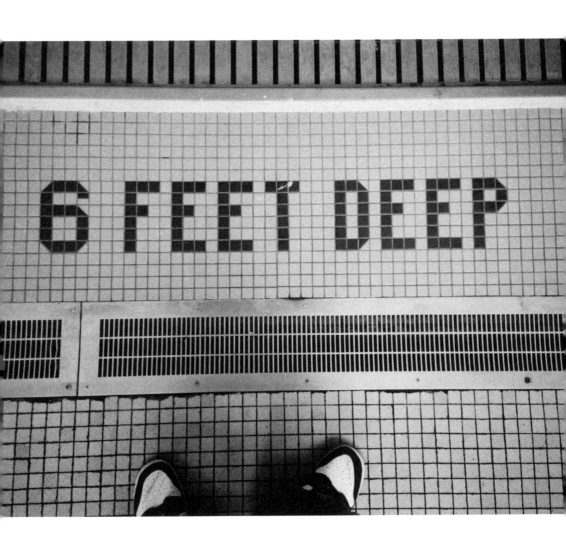

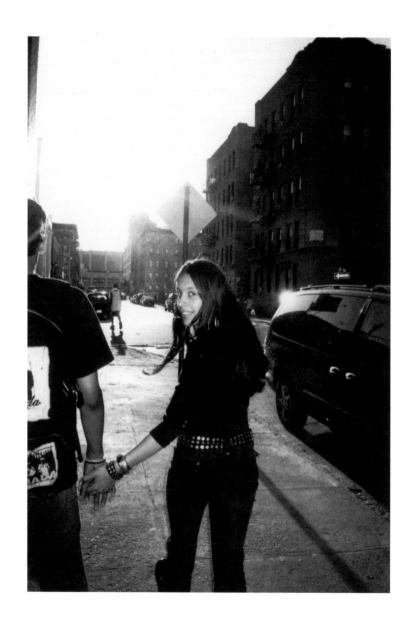

HANNAH SUNSET ★ FISH FOOD ★ AIRSTREAMS

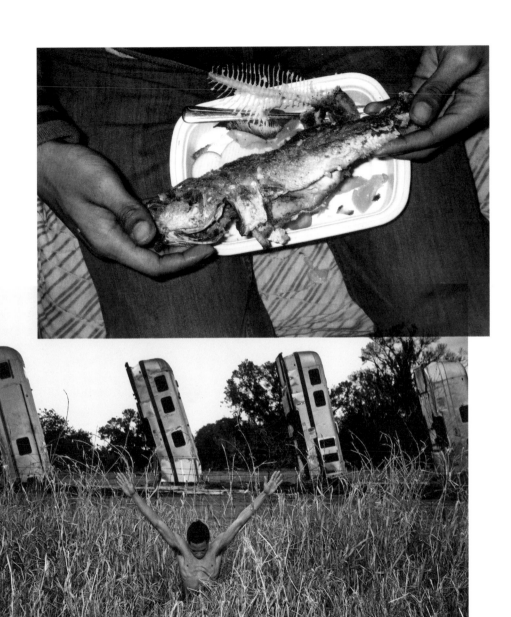

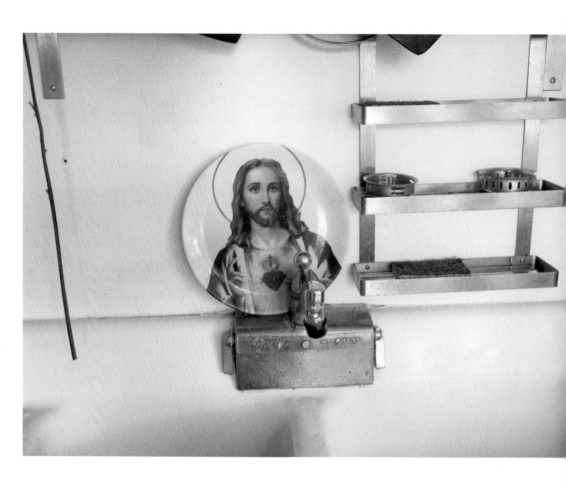

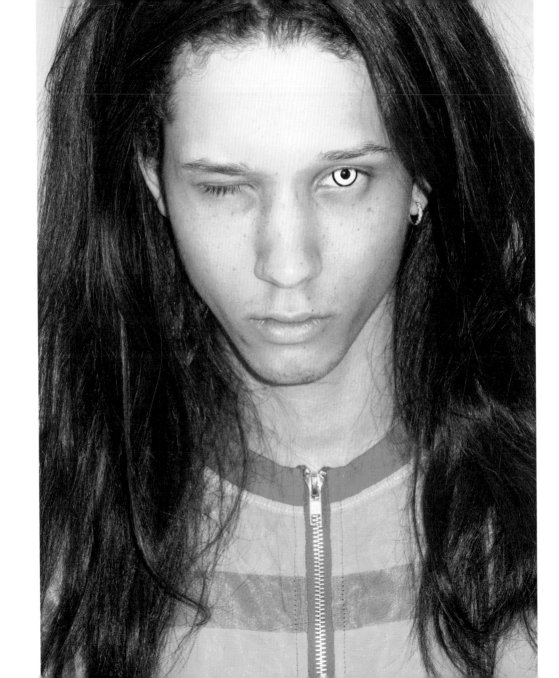

HI KEVIN—HOPE THIS ISN'T TOO GIDDY.

(IF ANY OF THE GRAMMATICAL LIBERTIES ARE TOO EMBARRASSING
PLEASE FEEL FREE TO ADJUST...)

CHEERS,
R

★

I REMEMBER WHAT IT'S LIKE TO BE IMMORTAL.
I REMEMBER HOW IT FEELS TO BE ONE OF EDGAR DEGAS' YOUNG SPARTANS.
I REMEMBER BEING ONE OF GUSTAVE MOREAU'S ANGELS OF SODOM,
 SELF CONSCIOUS INSOLENCE FLEXING IN THE SLEAZE.
I REMEMBER THE NAKED B.O. OF EGON SCHIELE'S SELF PORTRAITS.
I REMEMBER THE FLICK OF THE WRIST OF THE BANJEE QUEEN.
I REMEMBER THE SEX AND THE DEATH AND THE QUIET GLORY THAT I SEE
 IN KEVIN'S PICTURES.
IT'S AN ALMOST BIBLICAL VISION OF SMOULDERING YOUTH THAT'S PART
 OF THE SCAFFOLDING OF THE HISTORY OF ART.
BUT THERE'S AN UNDEFINABLE NEW TWITCH IN THE WARY SELF AWARE
 POSE AND EASY CUNNING THAT'S MODERN AND SMART.
WELCOME TO THE GOLDEN AGE OF CUNT.

ACKNOWLEDGMENTS

ABIAH HOSTVEDT
AKEEM SMITH
ALIX BROWNE
ANGELA CRAVENS
ANNA TREVELYAN
ANT, DANA, A.J., LEX & LILABEAN
BERRIN NOORATA
BOYCHILD
BRONX MUSEUM OF THE ARTS
CARRI MUNDUN
CHIOMA NNADIA
CHRIS BROWN
CL
COLLETTE HO
DEB, BILLY, HANS, BRIDGET, SUE,
 NERISSA & THE PHAIDON FAM
DESTINY FRASQUERI
EDDY LEROY JR.
ELIJAH ESQUIVEL AGURS
EPIC RECORDS
GASPARD LUKALI
GEORGE & DAVE @ RED
GINA BATTLE
GREG GARRY
HALEY WOLLENS
IAN ISIAH
INGRID SISCHY
JASON FARRER
JASPER BRIGGS
JIMMY ROCHE
JIMOTHY CEDENO McNAMARA
JULIE ANNE QUAY
KATIE CONSTANS

LONG NGUYEN
LUCA GUARINI
MALUCA MALA
MATTHEW HENSON
MICHAEL DAVID QUATTLEBAUM,
 AKA MYKKI BLANCO
MICKY AYOUB
NEVILLE WAKEFIELD
NICOLA FORMICHETTI
NOEL @ REQUEST
PRINCE FRANCO
RAUL LOPEZ
RICK OWENS
ROB MEYERS
ROBBIE SPENCER
ROBOT MOONJUICE
SAMUEL ZAKUTO
SARAH A. FRIEDMAN
SCHOOL OF VISUAL ARTS
SHAYNE OLIVER
TIM HEMMETER
MY PARENTS, TONY AND DEBORAH
TRAVIS SCOTT
TREVOR SWAIN
VENUS X
VIRGIL ABLOH
YURI PLESKUN

A VERY SPECIAL THANK YOU TO
MY SUBJECTS, MODELS, AND
SITTERS. YOU ARE THE IMPORTANTS.
YOUR HONESTY, ACCESS, AND
TRUST CREATED THIS BOOK.

FRONT ENDPAPERS: 33 MILES; BATHING DOVE
PAGE 1: USUAL SUSPECTS; 'FRO
PAGES 2—3: AMERICAN BUS STOP
OPPOSITE: JEWICE
BACK ENDPAPERS: ITALIAN STRAY DOG

PHAIDON PRESS LIMITED
REGENT'S WHARF
ALL SAINTS STREET
LONDON N1 9PA

PHAIDON PRESS INC.
65 BLEECKER STREET
NEW YORK, NY 10012

PHAIDON.COM

FIRST PUBLISHED 2016
©2016 PHAIDON PRESS LIMITED

ISBN 978 0 7148 7238 4

A CIP CATALOG RECORD FOR
THIS BOOK IS AVAILABLE FROM
THE LIBRARY OF CONGRESS
AND THE BRITISH LIBRARY.

COMMISSIONING EDITOR:
 WILLIAM NORWICH
PROJECT EDITOR:
 BRIDGET McCARTHY
PRODUCTION CONTROLLERS:
 SUE MEDLICOTT
 NERISSA DOMINGUEZ VALES
DESIGN:
 HANS STOFREGEN

PRINTED IN CHINA

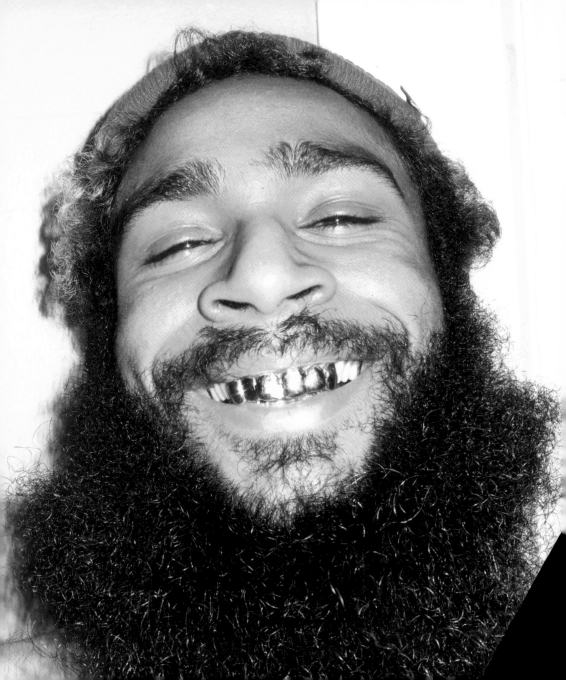